IMAGES
of America

DETROIT
CITY OF CHAMPIONS

IMAGES

of America

DETROIT
CITY OF CHAMPIONS

David Lee Poremba

ARCADIA

Published by Arcadia Publishing,
an imprint of Tempus Publishing, Inc.
2 Cumberland Street
Charleston, SC 29401

Printed in Great Britain.

Library of Congress Catalog Card Number: 98-83150

For all general information contact Arcadia Publishing at:
Telephone 843-853-2070
Fax 843-853-0044
E-Mail arcadia@charleston.net

For customer service and orders:
Toll-Free 1-888-313-BOOK

Visit us on the internet at http://www.arcadiaimages.com

This one's for Kate—
who puts up with it all.

CONTENTS

ACKNOWLEDGMENTS

Grateful acknowledgment is made to the following individuals and institutions that have contributed photographs to this book: Richard Bak, for pictures from his own collection; the staff of the Walter P. Ruether Archives of Labor and Urban Affairs at Wayne State University, especially Mike Smith, Tom Featherstone, and Mary Wallace for pictures from the *Detroit News* Collection, the Ernie Harwell Sports Collection of the Burton Historical Collection, Detroit Public Library, and the still photograph collection of the Burton; and Irene T. Poremba, for pictures from the stock-car race era of her youth.

INTRODUCTION

Professional sports have played an important part in the history of the people and the city of Detroit since the turn of the century. Detroit sports teams have given people an opportunity to relax and take a break from the pressures of day-to-day living. More importantly, perhaps, they have given the city a unique identity and provided the means to gain both a sense of pride in one's community and a unity of spirit. At no other time was this more evident than during the decades from the 1920s through the 1950s, when Detroit teams rose consistently to the top of their individual professions.

The Detroit Tigers had the monopoly on the majority of recreation dollars through the first two decades of this century. In 1926, Detroit was awarded a franchise in the National Hockey League and the Victoria, British Columbia, Cougars team was moved in. They changed their name to the Falcons and, under the new ownership of James Norris, finally became the Red Wings, a team that took a share of Detroit's sporting heart. After several unsuccessful attempts to establish a football franchise, the Detroit Lions finally gained a foothold and a following here in 1934. They did so with a spirited display of football talent, playing the Chicago Bears to a near standstill on that first Thanksgiving Day.

In 1935, the three professional sports teams in Detroit accomplished a remarkable feat by each winning their respective league titles and going on to capture the World Championships of baseball, football, and hockey, earning for the city of Detroit the honored sobriquet of "City of Champions." Here began a close and lasting relationship between Detroit sports teams and their fans, especially the people of the City of Detroit. Detroiters often live and die by their teams, no matter what sport they follow. And there are plenty to follow.

Sports in Detroit is a year-round occurrence. It all begins in the spring with baseball's opening day, joined in the summer by the hydroplanes on the Detroit River. Fall brings football, hockey, and basketball, all running concurrently throughout the rest of the year until it is spring again and the process begins anew.

The Golden Age of professional sports saw a proliferation of different sports. Football, boxing, and hockey became major sports to watch, and basketball showed that there was room for more. Nowhere was this more evident than in Detroit, where there was always a franchise being started. Dynasties rose and fell, and Detroit saw its share of them. There has always been something to celebrate.

This volume is a celebration of that era in professional sports in Detroit and a record of the contribution that the people and the City have made to the history and prosperity of those sports.

One

1920s

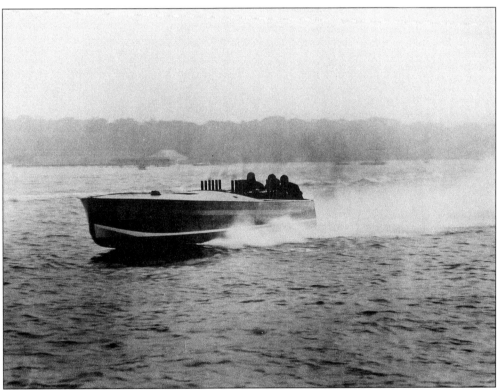

THE FIRST MISS AMERICA, 1920. Gar Wood's entry in the 1920 Harmsworth Trophy Race was *Miss America I* (pictured). English rules stated that all boats had to be built with parts and labor from the home country. Wood designed a new boat, using Packard-built Liberty engines. It cost him $250,000 to get the trophy. He finished ahead of all of the competition, averaging 62 mph on the course. After the English race, Wood hurried home to compete in the defense of his Gold Cup at Detroit. *Miss America I* set a new world record at 70 mph for three heats.

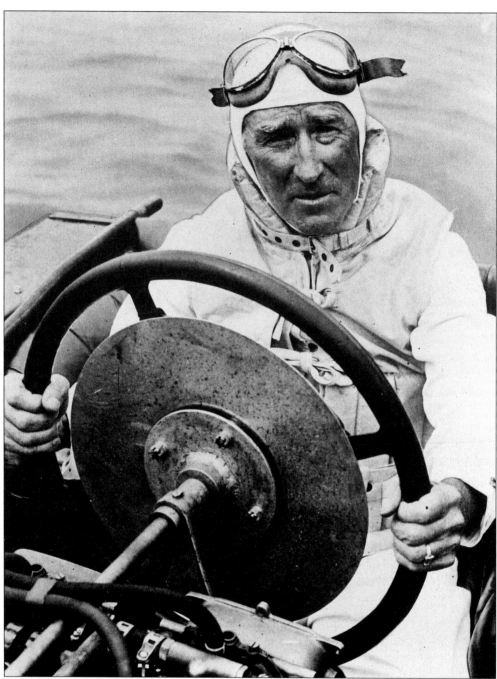

KING OF THE POWER BOATS, 1920S. The Gray Fox of Grayhaven, Garfield Arthur "Gar" Wood was an unknown inventor when he moved to Detroit in 1915 at the age of 35. He had no formal education in engineering but was a marvel at mechanics. Wood stood 5'6" and never weighed more than 130 pounds, but he had a huge appetite for speed and an imagination to match. In 1916, he bought the *Miss Detroit* as well as Algonac designer Chris Smith's boat plant. They built a new boat, and, in 1917, Wood won the Gold Cup Trophy again for Detroit. He kept that trophy until 1922, an unprecedented five consecutive years.

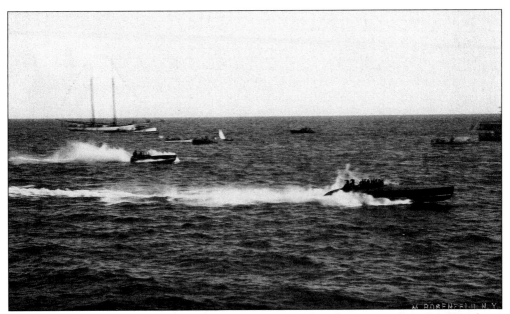

A Tough Race at Toronto, 1920s. It was not very often that anyone beat Gar Wood in a boat race—in fact, many people thought he was unbeatable. In what he called "the toughest race," Gar's boat was beaten by *Whip-po-will Jr.*, owned by Minneapolis businessman A.L. Judson. The irony lies in the fact that *Whip-po-will Jr.* was built in Detroit.

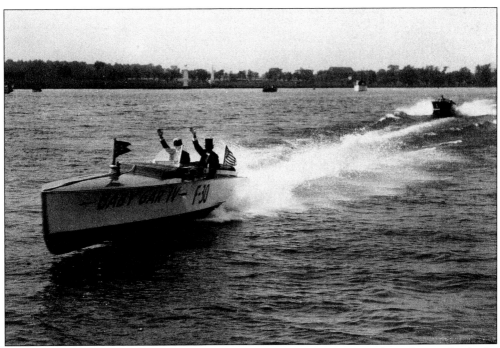

In Top Hat and Tails, 1924. Gar Wood and the ever-present Orlin Johnson finish the Fisher-Allison Trophy Race in fine style and proper attire. Compared to the intense competition in the Harmsworth and Gold Cup Races, this one must have been like a walk in the park.

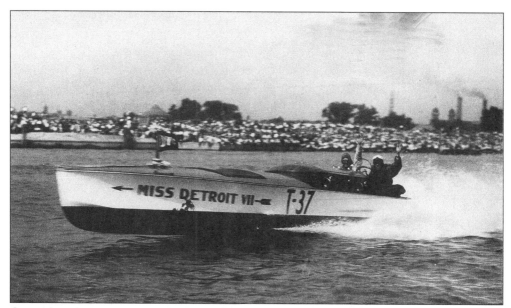

GOLD CUP RACER, 1925. *Miss Detroit VII* cruises past the spectator stands during the Gold Cup trials of 1925. These boats could approach the terrific speed of 50 mph on a calm surface. Although there was not a winner that year, the *Miss Detroit* series was the pride and joy of the Motor City. Caleb Bragg, driving *Baby Bootlegger*, took the Cup that year with an average speed of 48.4 mph.

THE ENGLISH COMPETITION, 1929. The *Estelle VII*, driven by Marion Barbara Carstairs, attempts to recapture the International Regatta Trophy from America and Gar Wood at the 1929 Harmsworth Race. Carstairs, an English heiress to Standard Oil's millions of dollars, was also a classical dancer, tennis player, and musician. She drove ambulances and motorcycles during World War I. This boat developed a gasoline leak and had to quit the race.

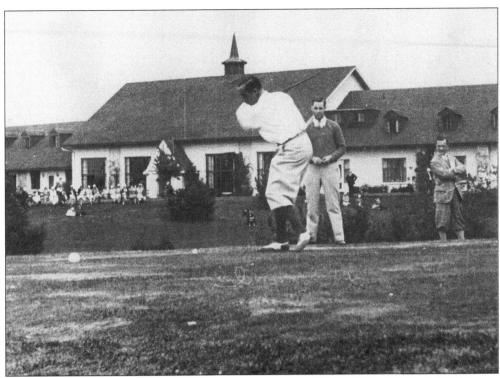

TEE OFF AT OAKLAND HILLS, 1920. Born in Rochester, New York, in 1892, Walter Hagen gained the attention of the golf world in 1913 when he finished a stroke behind the winner in the U.S. Open. After winning his second U.S. Open title in 1919, he moved to Michigan and became the first professional at the Oakland Hills Country Club. Walter maintained a long residence at Detroit's Book-Cadillac Hotel and was a member of the Detroit Athletic Club.

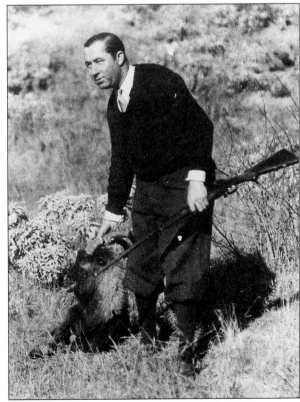

WALTER BAGS A BILLY, 1929. Taking time out from his golf tour, Walter Hagen participates in a wild goat hunt on Santa Catalina Island in California. Always a meticulous dresser, Hagen is seen here on his way to becoming a world-renown professional sportsman who would conduct world exhibition tours under the management of Bob Harlow.

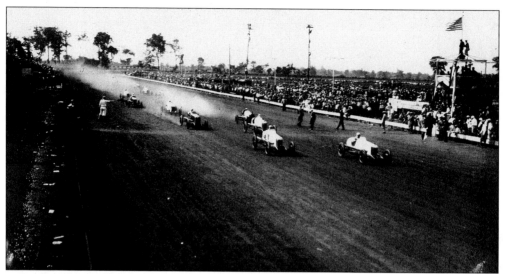

RACE DAY AT THE STATE FAIRGROUNDS, 1929. The race starter (dressed in white, on the left side of the track) raises his green flag to start the annual stock car race at the State Fairgrounds at 8 Mile Road and Woodward Avenue. These speedsters hit top speeds of nearly 35 mph. The finishers were the ones with the best maintained—not necessarily the fastest—cars.

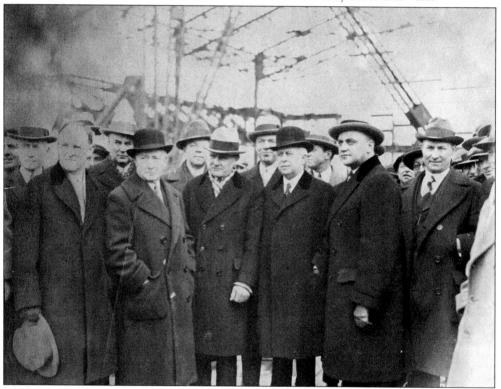

LAYING THE CORNERSTONE, 1926. Frank Calder (third from left), president of the National Hockey League, and Detroit Mayor John Smith are among the dignitaries present at the laying of the cornerstone of the Olympia Stadium in 1926. Construction delays set the opening of the arena back to October 1927.

14

CONSTRUCTION OF THE BIG RED BARN, 1926. The steel skeleton of the Olympia roof begins to take shape after construction delays forced the Red Wings to continue league play at Windsor, Canada. The Arena was built at a cost of $1,259,300 and had a Romanesque design on the outside and 74,800 feet of piping for refrigeration on the inside. The entrance could accommodate 13 retail stores.

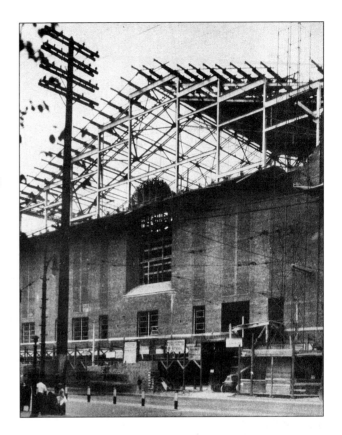

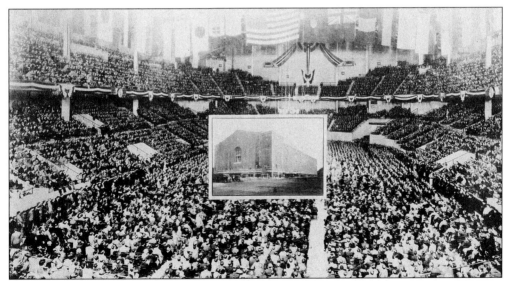

OPENING NIGHT AT OLYMPIA, 1927. The inset photograph shows the new Olympia Stadium on Grand River Avenue and McGraw. Designed by Charles Howard Crane, it housed the largest indoor skating rink in the country, with a seating capacity of 13,000. Crane was better known for his theater designs, including the Capitol, the State, and the grandest of them all, the Fox. The Olympia was at its full capacity on this October night for a boxing match.

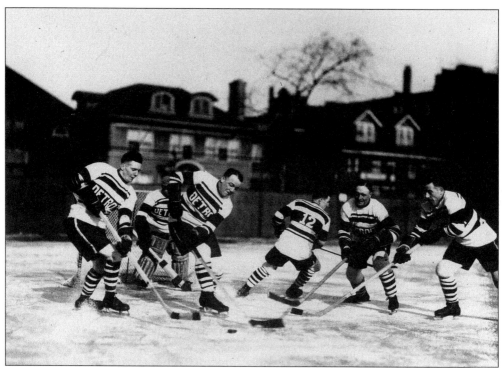

SQUAD SCRIMMAGE, 1927. These Detroit Cougars hold a practice scrimmage at Northwestern Field, across the street from Olympia, in order to get used to the new rule changes. Hap Holmes is in goal, and number 12 is right winger Larry Aurie. Some of the rule changes included the two-line pass.

PRACTICE MAKES PERFECT, 1927–1928. The Detroit Cougars continue to scrimmage at Northwestern Field during the seasons' off-days. The two-on-one setup play didn't work this time, but that's what practice is for. They practiced a new rule change, as forward passing was now allowed in the defending zones.

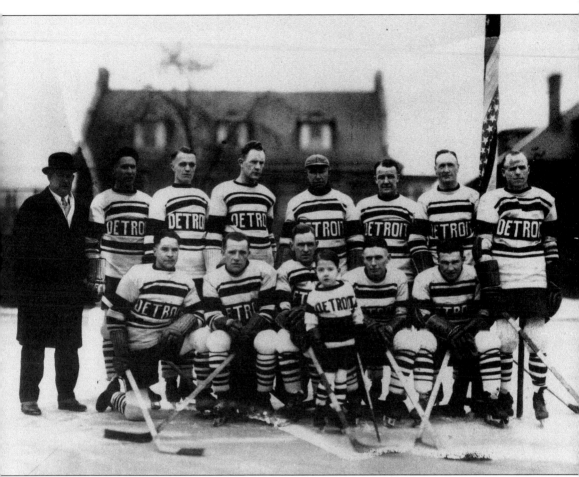

THE DETROIT COUGARS, 1927–1928. The Detroit Cougars take time out to pose for a formal team portrait in 1927. Some of the players who can be identified are Coach Jack Adams (far left); (seated or kneeling) Jack Sheppard, Carson Cooper, and Larry Aurie; (standing) Gord Fraser (third from left), Hap Holmes, Reg Noble, and Frank Foyston. The Cougars wore this particular jersey for the 1927–1928 season and finished fourth, just above Chicago, in the American Division with a 19–19–6 record.

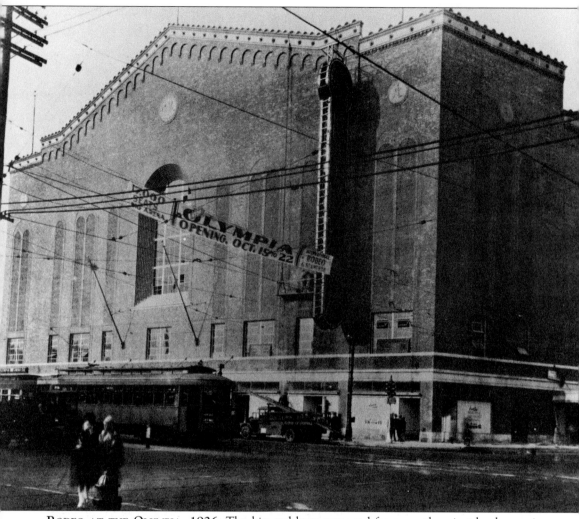

RODEO AT THE OLYMPIA, 1926. The big, red barn was used for more than just hockey as is evident from the banner hanging across Grand River announcing an international rodeo. With no ice surface, an additional 4,000 seats could be added to accommodate political rallies, rodeos, or boxing matches.

Two

1930s

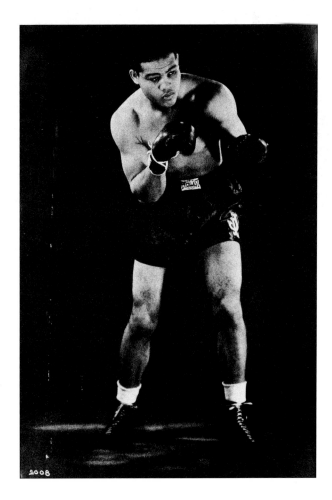

THE HEAVYWEIGHT CHAMPION OF THE WORLD. When Joe Louis announced his retirement from boxing on March 1, 1949, he joined Jim Jeffries and Gene Tunney as the only modern heavyweight champions to retire holding the title; all the rest had lost it in the ring. He had won 60 of 61 professional bouts, 51 of them by knockout. He wore the championship belt for 11 years and 8 months, and he successfully defended his title 25 times, both of which remain records. Louis would come out of retirement in 1950 to fight ten more times and record three knockouts among eight wins, with only two losses.

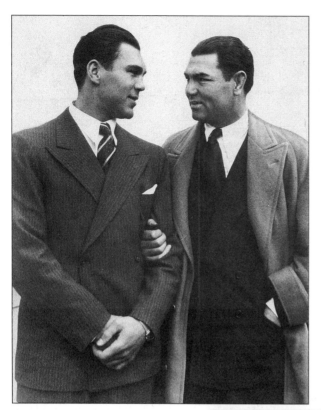

TWO OF BOXING'S GREATEST, 1933. Max Schmeling (left) chats with another world champion, Jack Dempsey, in New York. Dempsey won the World Heavyweight title in 1919, and defended it six times before losing to Gene Tunney in 1926. Schmeling won the title in 1930 and lost to Jack Sharkey in 1932.

THE CROAT FROM HOCKING, IOWA. Johnny Miler came to Detroit to work on the assembly line. Soon laid off, and with nothing else to do, he took up boxing under manager Billy Stewart. In early 1932, he was scheduled to fight another promising student, Joe Louis, in a three-round fight at the Naval Armory. In Louis's first organized fight, Miler knocked him down no less than seven times. Miler went on to become the first Detroit boxer to compete in the Olympics.

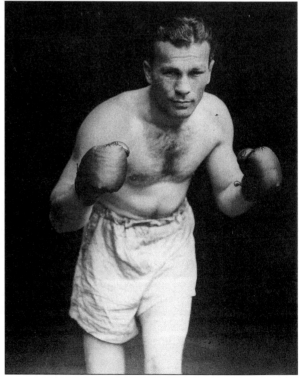

ON THE ROAD TO GREATNESS, 1935. Joe Louis stands victorious over Patsi Perroni on January 4, 1935, at Olympia, where he won his first fight of the new year in a ten-round decision. It was the 13th victory of his career; he would go on to win 13 more fights that year.

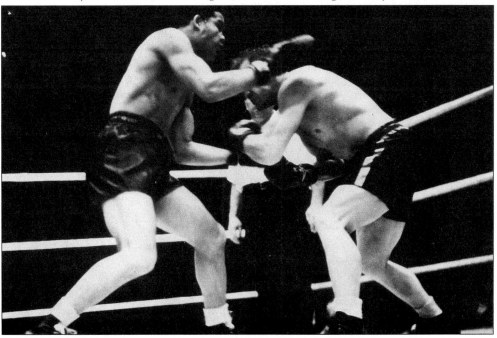

TITLE FIGHT, 1938. Boxing champion Joe Louis (right) defends his world title against Minnesota contender Harry Thomas in Chicago on April 1, 1938. Knocking out Thomas late in the fifth round, the Brown Bomber successfully defended his title two other times in 1938. He eventually retired as a champion.

THE REMATCH HEARD AROUND THE WORLD, 1938. On June 22, 1938, in New York City, Joe Louis defeated Max Schmeling by a knockout in the first round to retain his heavyweight crown. Louis's only previous professional loss was to Schmeling, in June 1936. This rematch had heavy political implications in U.S.–Nazi Germany relations.

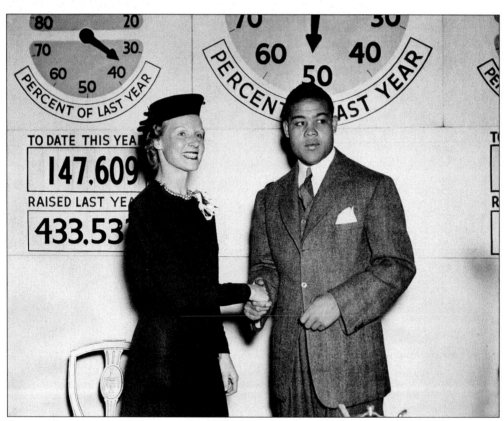

PUBLIC RELATIONS, 1939. Mrs. John N. Failing introduces the heavyweight champion of the world at a Community Fund luncheon held inside the Statler Hotel in Detroit. Mrs. Failing, chair of the committee, introduced Louis as an untiring worker. He had four successful title fights that year and was one of the most recognizable sports figures of the 1930s.

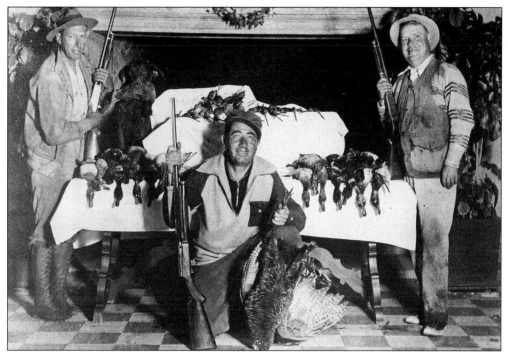

BAGGING BIRDIES WITHOUT A PUTTER, 1932. Walter Hagen is flanked by two other pros from the Miami Biltmore Country Club, Jack Vilas (left) of Chicago and Eddie Barker (right) of Miami. Hagen developed a reputation as an all-around sportsman and was a phenomenal shot with a rifle. As with most sporting nomads, he often went south for the winter.

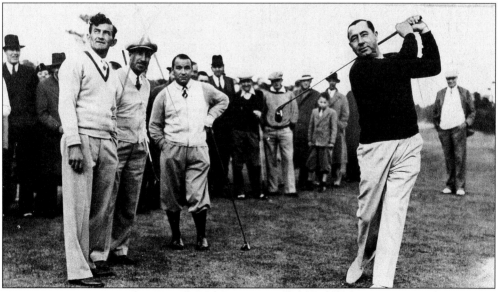

FOUR CHAMPIONS WARM UP, 1936. From left to right are Johnny Revolta, defending PGA champ; Tony Manro, 1932 U.S. Open champ; Gene Sarazen, former U.S. and British Open champ; and Walter Hagen, five-time winner of the PGA title. They are participating in the last practice round before competition begins at the Pinehurst Country Club course in Pinehurst, North Carolina.

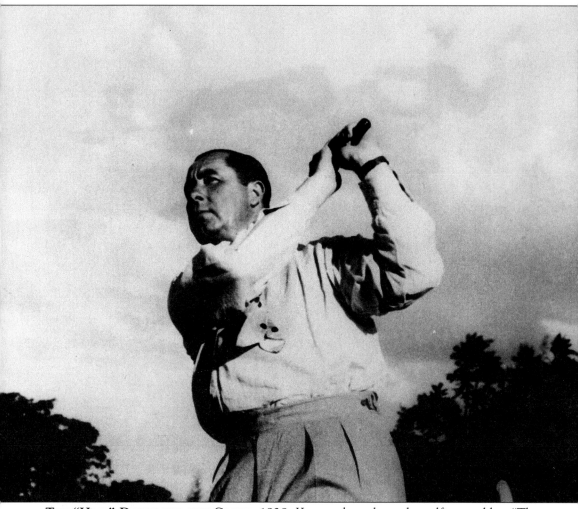

THE "HAIG" DRIVES FOR THE GREEN, 1938. Known throughout the golfing world as "The Haig," Walter Hagen was one of the first figures in professional sports to earn $1 million doing what he did best—play golf. He is one of golf's immortals, having won four British Open titles, five Professional Golfer's Association crowns, and five Western Open titles in a career that saw him battle on five continents. He is the man who opened country club doors to golf professionals by breaking the rules in England where tradition barred pros from the clubhouse. He was the favorite golfing partner of the Prince of Wales (Edward VII); Hagen once kept him waiting on the first tee for half an hour, and shocked the British by calling him Eddie instead of Your Highness. Walter made his home at Inwood, a 20-acre estate near Traverse City, Michigan. He died of throat cancer in October 1969.

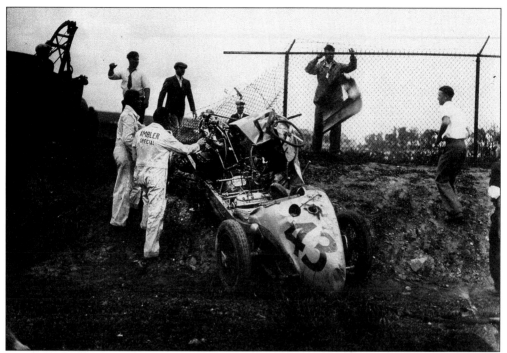

FANTASTIC CRASH, 1930. The *Ambler Special* ended her competition in a spectacular crash during a race in June 1930, possibly at the stadium on the campus of the University of Detroit. Here, the pit crew takes care of what is left of the car after the driver has been rushed to the hospital to be treated for his injuries.

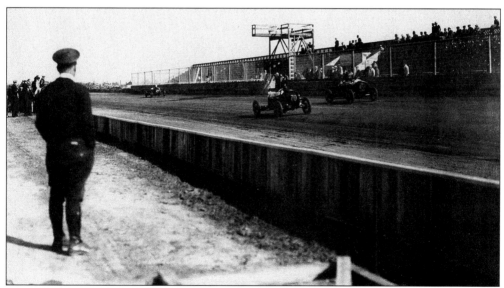

NO SPEEDING TICKETS HERE, 1932. This motorcycle cop watches the action at the brand-new Motor City Speedway, a track built especially for the growing sport of auto racing. The speedway was located at 8 Mile Road and Schoenherr and had grandstands for viewing the races. The tower in the middle is for the race starter.

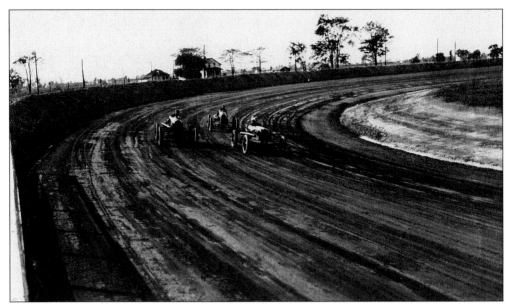

AROUND THE FAR TURN, 1932. Headed down the home stretch are these three finishers in the fall of 1932. Races were always held weather permitting; this track looks dry and solid, giving the drivers opportunities for record lap speeds. There were several races held on race day, including elimination races leading up to the 20-lap feature race.

MIDGET RACING, 1935. Frank Brisko, a veteran driver who was more at home in the Indianapolis 500 races, tries his hand at piloting the "midget" class of racer. The race was held in early September at the University of Detroit stadium at Livernois and 6 Mile Road. This class of car, which was restricted to one seat, was required to reach a certain length to compete.

A 1939 PROGRAM. This program gave race fans an opportunity to "keep score" by entering drivers' names and car numbers for each race on the program that evening. There were 24 entries to qualify for the feature race and five elimination races. The first two cars to finish in each race would qualify. Races were held every Monday and Thursday night, weather permitting, and began promptly at 7 pm.

TEN GRACIOUS LADIES, 1930S. Gar Wood and Orlin Johnson are surrounded by ten fabulous "misses" who won them the coveted Harmsworth Trophy nine times since 1920. These boats were built successively larger and proportionately faster. The Harmsworth was for hydroplanes of unlimited power but with a restricted length of 40 feet. The trophy was awarded to the country whose boat won two of the three races.

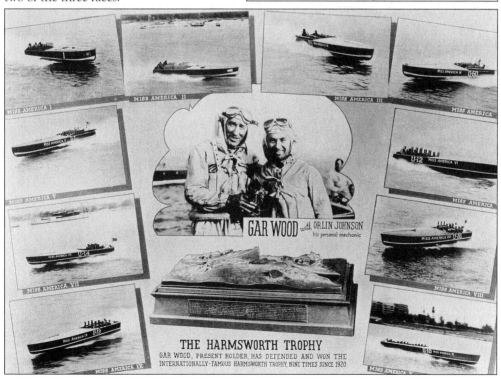

THE HARMSWORTH TROPHY
GAR WOOD, PRESENT HOLDER, HAS DEFENDED AND WON THE
INTERNATIONALLY-FAMOUS HARMSWORTH TROPHY, NINE TIMES SINCE 1920

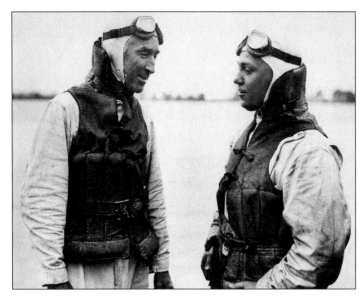

DISCUSSING RACE STRATEGY, 1930S. Gar Wood (left) and Bud Shaver discuss their tactics prior to the Harmsworth Trophy Race. The costliest trophy in speed-boat competition, it was donated in 1903 by Lord Northcliffe (Sir Alfred Harmsworth) and was awarded to the winner of the International Regatta. Wood, in his *Miss America* series boats, had won the trophy nine times since 1920.

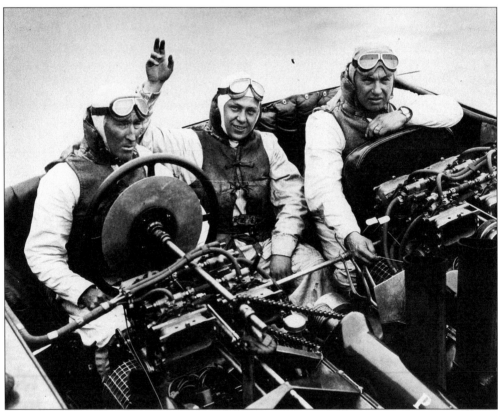

AT THE CONTROLS, 1932. Pictured from left to right are Gar Wood, Bud Shaver, and Orlin Johnson at the helm of *Miss America* X during the trial heats of the 1932 Harmsworth Race. Orlin Johnson was Wood's personal mechanic and sat next to him to operate the throttles while Wood did the steering. Because of the tremendous noise, they communicated with hand signals.

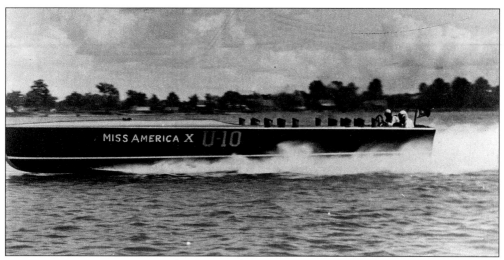

MISS AMERICA X, 1933. Gar Wood's entry into the 1933 Harmsworth Race was 38 feet long and powered by four 12-cylinder Packard motors capable of 6,800 horsepower. She weighed nearly 10 tons. Each race consisted of five laps over a 7 nautical-mile course. This race was in the St. Clair River at Marine City.

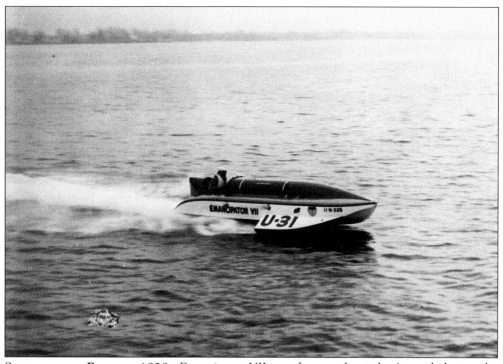

STREAMLINED RACERS, 1939. *Emancipator VII* speeds past the judges' stand during the American Power Boat Association Gold Cup Race of 1939. The boats are beginning to take on a more recognizable shape as technology evolves. The Miss Detroit Power Boat Association sponsored. *My Sin* won the event, averaging a speed of 67 mph.

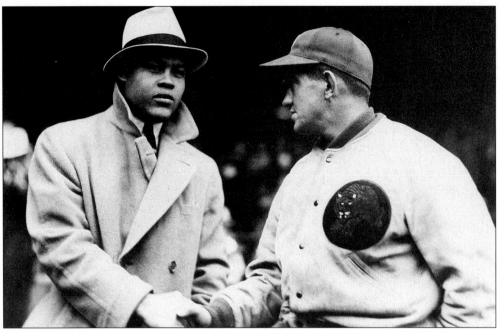

TWO CHAMPIONS MEET, 1936. Joe Louis shakes hands with Detroit Tigers manager Mickey Cochrane in the spring of 1936 at the ball yard. In a City of Champions, Louis would take his place as champion the following June, defeating James Braddock to become the heavyweight champion of the world, joining the Tigers, Lions, and Red Wings.

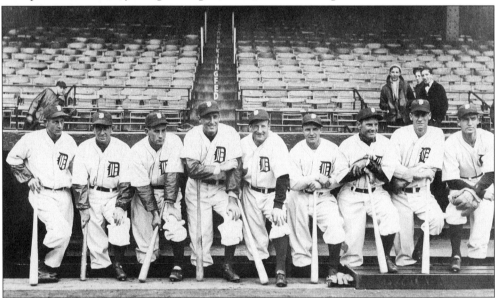

THE DEPRESSION-ERA CHAMPIONS. Here is the starting line-up of the team that delivered back-to-back pennants and a World Championship. Arranged by their position in the batting order, they are from left to right as follows: Jo-Jo White, centerfield; Mickey Cochrane, catcher; Charles Gehringer, second base; Hank Greenberg, first base; Goose Goslin, left field; Billy Rogell, shortstop; Gee Walker, right field; Marv Owen, third base; and Schoolboy Rowe, pitcher.

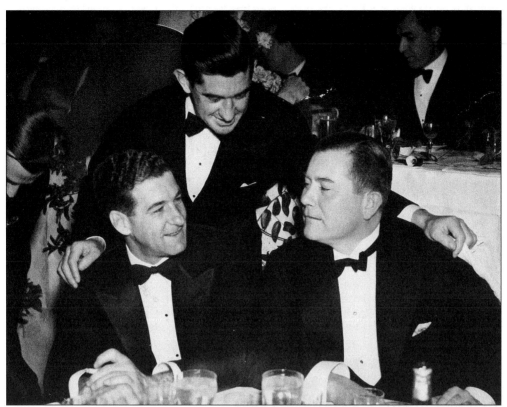

TIGER MANAGEMENT, DRESSED TO KILL, 1930S. Mickey Cochrane stands between Bucky Harris (left) and owner Tom Yawkey (right) at a black-tie affair in the mid-1930s. Cochrane replaced Harris as the Tigers' skipper at the end of the 1933 season, and Tom Yawkey, the son of former team owner William Yawkey, had baseball interests in Boston and Detroit.

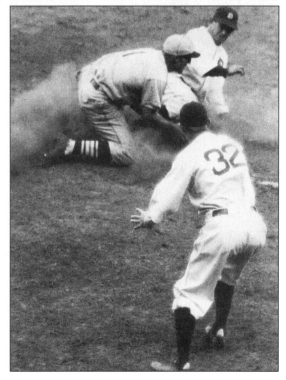

THE CALL THAT BROKE THE SERIES, 1934. Mickey Cochrane slides safely into third base in the bottom of the sixth inning of game six. Goose Goslin sacrificed with runners on first and second and no outs to spark a Bengal rally and put Dizzy Dean's brother, Paul, on the ropes. American League umpire Buck Owens called him out, and with that call, deflated the team's confidence.

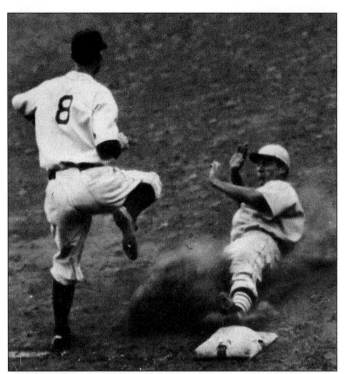

THE PLAY THAT STARTED THE RIOT, 1934. St. Louis Cardinals left fielder Ducky Medwick slides hard into third base on an easy triple in the sixth inning of game seven. Tigers third sacker Marv Owen stepped on his right foot, and Medwick kicked him three times. Medwick took his position at the bottom of the inning, and Tiger fans pelted him with fruit, bottles, and anything else they could throw.

COMMISSIONER'S DECISION, 1934. From his front-row box seat along the third base line at Navin Field, commissioner of baseball Judge Kenesaw Mountain Landis watches Detroit fans show their displeasure in left field. In the center of the photo is Cardinals left fielder Ducky Medwick, who was put out of the game by Landis to calm the irate Tiger fans. St. Louis won the game 11–0.

LEADER OF THE BAND, 1935. Billy Rogell, Tiger shortstop and later city councilman, leads the parade at Navin Field festivities to open the 1935 baseball campaign. Billy would post a .275 batting average and lead the league with 104 double-play assists and a fielding average of .971 at his position.

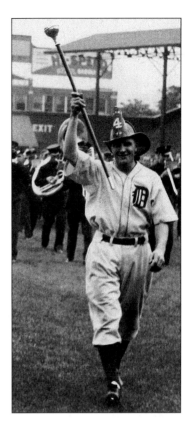

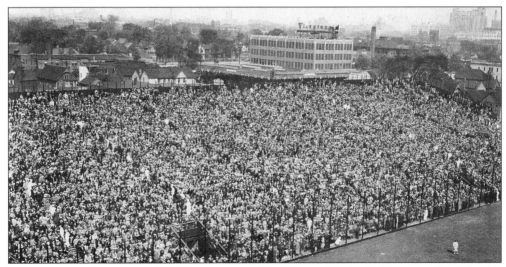

NAVIN FIELD, OCTOBER 1935. The temporary bleachers at Navin Field are overflowing with Detroit fans preparing for the first game of the World Series against the Chicago Cubs on October 2, 1935. Chicago scored twice in the first inning on hits by Galan and Hartnett, and Cubs pitcher Warneke went the distance to post a four-hit shutout.

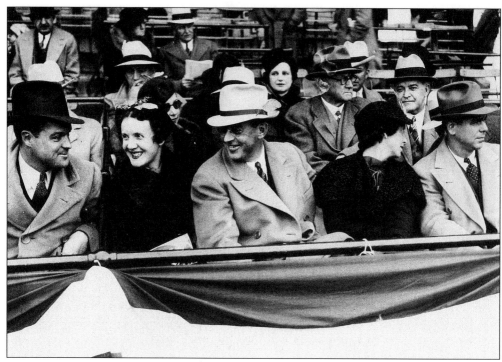

A VIEW OF THE OWNERS BOX, 1935. Pictured from left to right, Mrs. P.K. Wrigley, Mr. P.K. Wrigley, Mrs. George Getz Jr., and Mr. George Getz Jr. are all smiles as their Cubs coast to a 3–0 victory over the American League champs. The Wrigleys were the reigning crowned heads of the chewing gum empire.

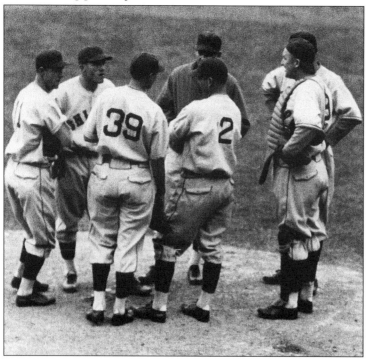

CUB CONFERENCE ON THE MOUND, 1935. The Tiger attack in game two brought about this Cubs confab in the first inning. Singles by Jo-Jo White and Charley Gehringer and a double by Mickey Cochrane, followed by Hank Greenberg's home run, brought Cubs management hurrying out on the field. Charlie Root, the starting pitcher, caught an early shower.

34

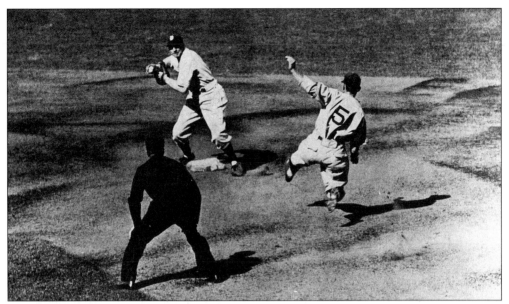

Twin Killing, 1935. The Bengal defense sparkled in the second game. Cubs second baseman Billy Herman grounded to pitcher Tommy Bridges, who turned and fired to Billy Rogell, forcing left fielder Galan. Shortstop Rogell finished the double play to first baseman Hank Greenberg. Galan had worked Bridges for a walk to start the game. The Tigers went on to score an 8–3 victory.

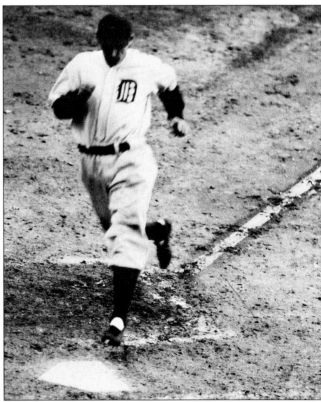

The Tiger Trots Home, 1935. Right fielder Pete Fox scores in game two as the Tigers trounce the Cubs in an 8–3 win. Fox led the Bengal attack with one triple, three doubles, and ten singles to post a .385 batting average. He would also drive in four runs.

THE G-MAN SCORES ONE, 1935.
Second baseman Charley
Gehringer scores the go-ahead run
in the eighth inning of game three
to give the Tigers a temporary
lead. The Cubs would tie the game
in the ninth inning, but the home
team would prevail in 11 innings.
Charlie would post a .375 batting
average for the series.

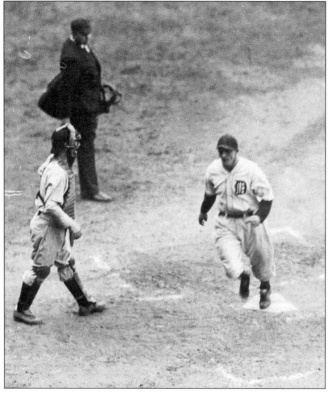

ROGELL SCORES ONE, 1935.
Shortstop Billy Rogell scores
in game six as the home team
matches the Cubs' 12 hits but
scores four runs to take the
series in six games. Rogell
batted .292 for the campaign
with four runs batted in. He
had seven singles and two
doubles in 24 at-bats.

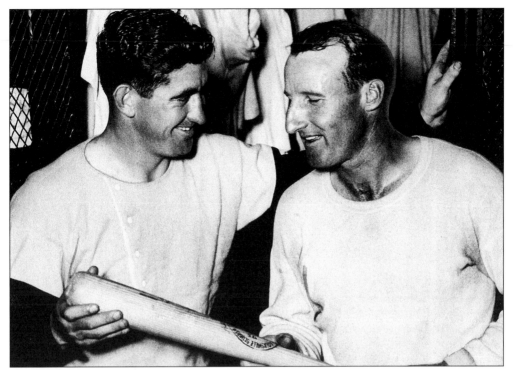

THE MAGIC BAT, 1935. Mickey Cochrane (left) and Goose Goslin examine the bat that brought home the World Championship. Goslin's single in the ninth inning sent Cochrane home with the winning run as the Tigers defeated the Cubs in game six with a 4–3 score. The city exploded into celebration.

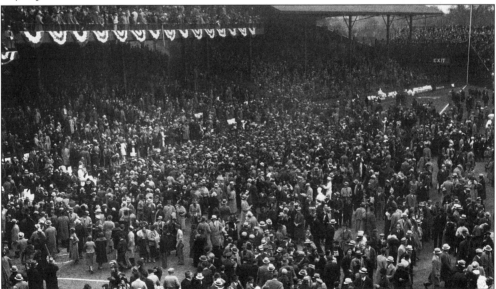

JUBILANT CROWD AT NAVIN FIELD, 1935. The celebration begins at the corner of Michigan and Trumbull as the Tigers bring home their first World Championship since 1887. Goslin's single scores Cochrane in the bottom of the ninth for a 4–3 victory. After splitting the first two games at home, the Bengals won three out of the next four to take the crown.

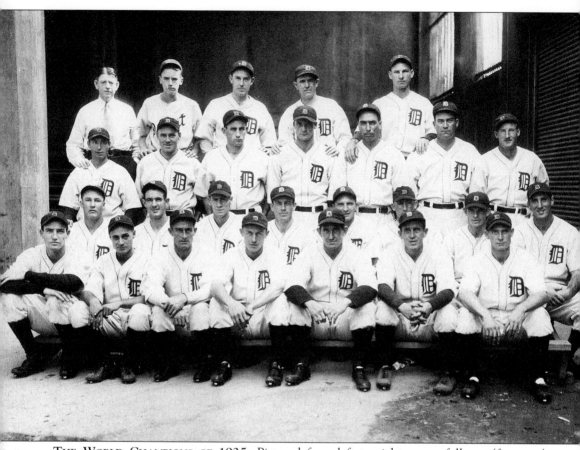

THE WORLD CHAMPIONS OF 1935. Pictured from left to right are as follows: (first row) Schoolboy Rowe, Herman Clifton, Coach Del Baker, Joyner White, Mickey Cochrane, Coach Cy Perkins, and Ervin Fox; (second row) Rudy York, Elden Auker, Marvin Owen, Ray Hayworth, Bill Rogell, Vic Sorrell, Tom Bridges, and Henry Greenberg; (third row) Hank Schuble, Frank Doljack, Charlie Gehringer, Luke Hamlin, Elon Hogsett, Fred Marberry, and Goose Goslin; (fourth row) Trainer Carroll, bat-boy Willis, Charley Fischer, Alvin Crowder, and Gerald Walker. The Detroit Tigers won the American League pennant with a 93 and 58 won-lost record for a .616 winning percentage. They went on to win the World Championship by defeating the Chicago Cubs 4–2.

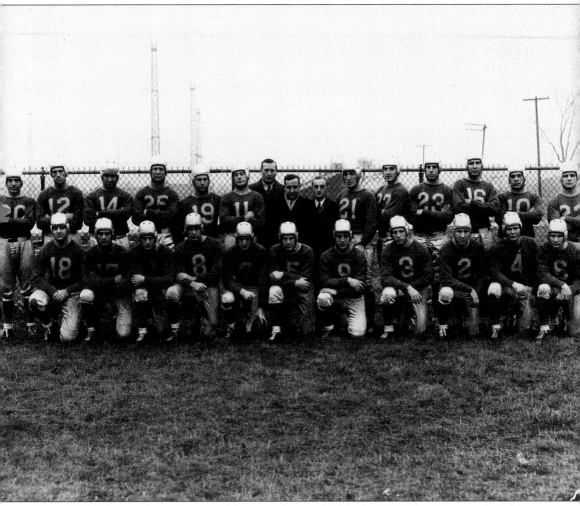

THE 1935 WORLD CHAMPIONSHIP DETROIT LIONS. In March 1934, the Portsmouth, Ohio Spartans were sold to a Detroit syndicate headed by George A. Richards, who owned radio station WJR. He moved the team to Detroit and, in keeping with the jungle cat theme started by the Tigers, renamed his team the Lions. They played at the University of Detroit's Dinan Field and came close to winning it all that year. Coached by "Potsy" Clark and staffed by football greats such as Dutch Clark (#7), Ernie Caddel (#1), Harry Elding (#11), and Ox Emerson (#20), these Lions finished first with a 7–3–2 record. They defeated the New York Giants 26–7 in front of 15,000 fans to claim the World Championship.

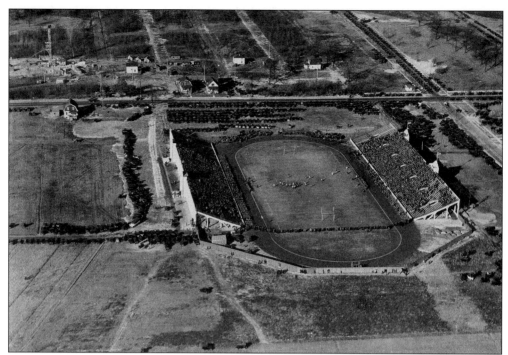

THE LION'S DEN, 1930s. The University of Detroit's Dinan Field was home to the Detroit Lions from 1934 to 1938, when they moved to Navin Field. But other Detroit professional football ventures were also played here. In 1928, the Detroit Wolverines called the field home; after all, the rent was cheaper than at Navin Field, and the city wasn't really ready for the sport. The 1934 Lions paid $400 per game rent.

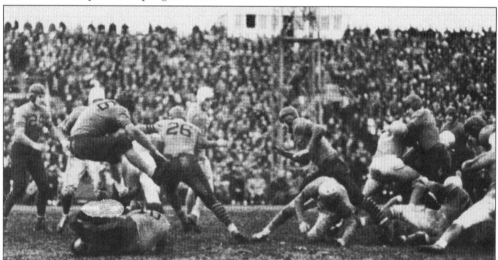

THE FIRST THANKSGIVING, 1934. Lions owner G.A. Richards took a chance on football fans when he scheduled the first Thanksgiving Day game in 1934. The first holiday bash pitted the Lions against the Chicago Bears and football great Bronco Nagurski. The Lions had reeled off ten straight victories, seven of them shutouts, before losing to Green Bay 3–0 just four days before. The Bears won 19–16, ending title hopes in Detroit but winning many converts to the sport.

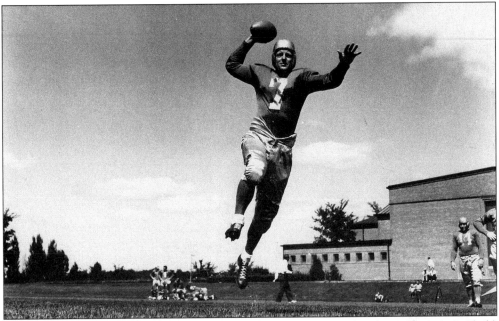

HIGH FLYING LION, 1935. Earl "Dutch" Clark (no relation to head coach "Potsy" Clark) played college football at Colorado and was an Associated Press All-American in 1928. He became an All-Pro quarterback at Portsmouth in 1931, before taking a coaching position at the Colorado School of Mines. Coaxed into returning when the team moved to Detroit, he continued his excellent running and passing game.

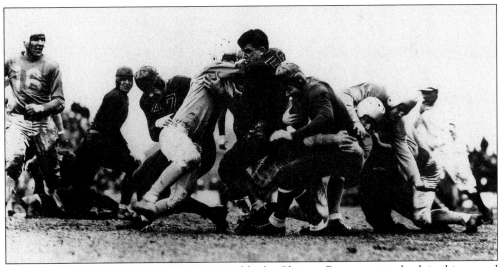

A SWARMING DEFENSE, 1935. The Lions tackle the Chicago Bears running back in this second Thanksgiving Day Classic rematch. In front of 18,000 fans, the Lions defeated the Bears 14–2 after tying them at Soldiers Field four days prior. Detroit would defeat the Brooklyn Dodgers for their last victory before meeting the New York Giants for the title.

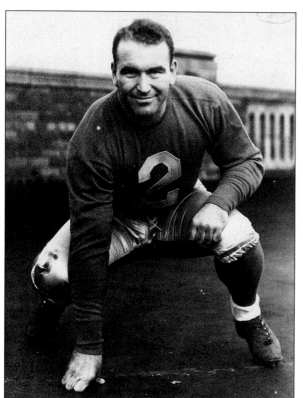

GEORGE "TARZAN" CHRISTENSEN, 1935. A carryover from the Portsmouth, Ohio Spartans, George Christensen was a tackle who played college ball at Oregon and was a key element in Detroit's vaunted running attack. He and Dutch Clark were the only Lions to be named to the All-Pro team in 1934, which was the team's breakthrough season with the fans.

TRAINING CAMP, 1937. Exactly which principles of action / reaction these players are trying to prove isn't clear, but practice they must here at Cranbrook. George "Potsy" Clark resigned as head coach and general manager of the team and was replaced by backfield star Earl "Dutch" Clark. He led the Lions in scoring and to a third-place finish with a 7–4 record.

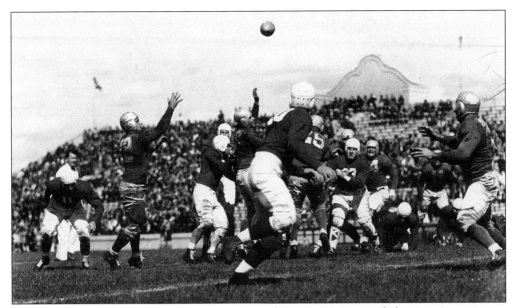

OPENING DAY VICTORY, 1939. The Lions opened the 1939 season with four victories, starting with this 21–13 win over the Chicago Cardinals. Lions quarterback Dwight Sloan threw only three interceptions in 102 attempts (a team record), as Detroit won six of their first seven games. They dropped their last four games to finish third at 6–5, their sixth consecutive winning season.

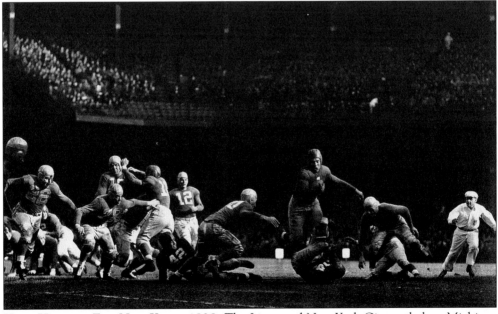

HIGH HURDLES FOR NEW YORK, 1939. The Lions and New York Giants clash at Michigan and Trumbull on November 5, a game the Lions won 18–14, snapping the Giants' 15-game undefeated streak. Phillip Martinovich kicked three field goals, and Chuck Hanneman kicked one, while the Giants missed four attempts. Note the referee dressed to resemble the ice-cream man.

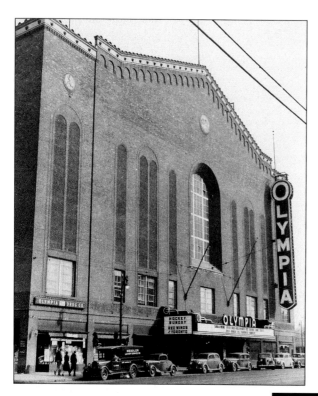

HOCKEY GAME ON SUNDAY, 1930s. The marquee at Olympia announces a Red Wings–Maple Leafs game coming on Sunday. Sonja Henie and her Hollywood Ice Revue would perform here on January 2–8. This may be an advertisement for the game played on Christmas Day in 1930, which was a long-standing tradition in Detroit.

LEROY GOLDSWORTHY. "Goldie" Goldsworthy was acquired by the Detroit Falcons (as the Red Wings were known then) from the London, Ontario franchise in the Canadian Pro League; he played two seasons before being sent to the Chicago Black Hawks. Goldy had three goals and six assists for nine points in the 1932–1933 season.

DETROIT FALCONS CENTERMAN, 1936. Strong, quiet, and capable was Marty Barry, who was acquired in a trade with Boston for Cooney Weiland in 1936. In the drive to repeat as Stanley Cup champions, Barry missed the scoring title by three points and won the Lady Byng Trophy in 1937 for combining sportsmanship and ability. He had two goals and one assist in the fifth and deciding final game.

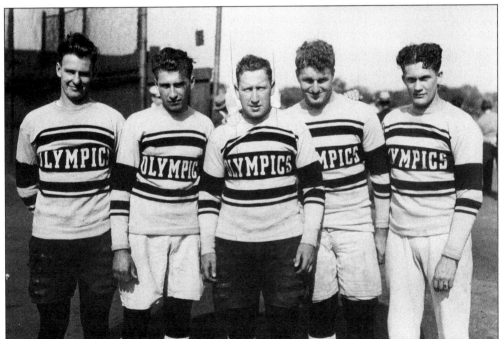

NHL HOPEFULS, 1935. Members of the Detroit Olympics farm club, pictured from left to right, are as follows: Ronald Hudson, Joe Schack, Don Deacon, Joe Bretto, and John Sherf. In the 1940s, Hudson, Deacon, and Sherf played for the Rangers, and Bretto played for Chicago.

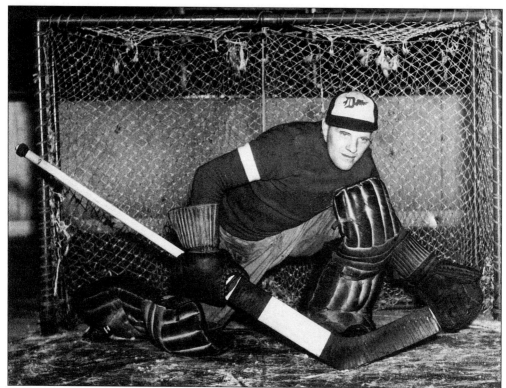

ONE THAT GOT AWAY, 1935. Walter "Turk" Broda is seen here in a Red Wings practice jersey, trying to make the team. A member of the Wings farm club, Broda was later sent to Toronto, where he began a 15-year, hall-of-fame career minding the nets for the Maple Leafs.

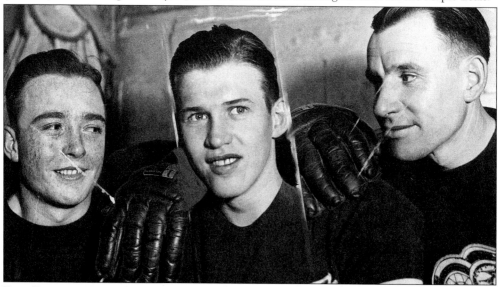

FINE FORWARD LINE, 1935. Pictured from left to right are Eddie Wiseman (right wing), Syd Howe (center), and Johnny Sorrell (left wing). They scored a combined 40 goals and 41 assists for Detroit that year. Wiseman was sold to New York early in the 1935–1936 campaign, while Sorrell and Howe would have scoring roles in the Stanley Cup win.

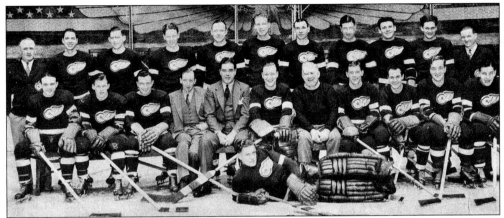

THE NATIONAL HOCKEY LEAGUE CHAMPIONS, 1935–1936. The NHL champions take time out for a formal team photograph on the Olympia ice after winning their first Stanley Cup. After making it to the finals in 1933 and losing to the Chicago Black Hawks 3–1 (in a best-of-five series), the team won the league championship and beat both the Montreal Maroons in the semi-finals and the Toronto Maple Leafs in the finals.

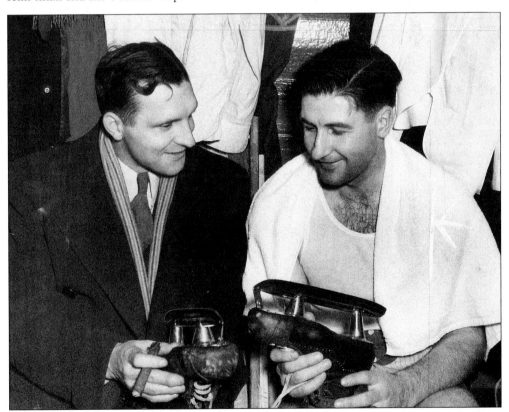

YOU PLAY ON THESE?, 1936. Detroit Tiger shortstop Billy Rogell can't imagine himself on skates as he chats with Red Wing centerman Marty Barry during the Wings' rush to their league banner. Barry came over from the Boston Bruins in early 1936, contributing 17 goals and 27 assists that season. He was sold to the Montreal Canadiens after the 1938–1939 season and was elected to the hall of fame in 1965.

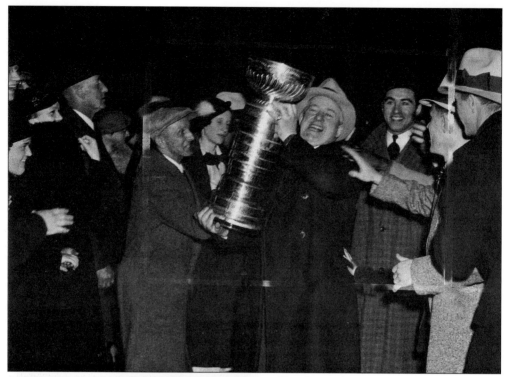

THE FIRST STANLEY CUP, 1936. Head coach Jack Adams hoists the Stanley Cup to the cheers and congratulations of Detroit fans shortly after the team's triumphant return from Maple Leaf Gardens in Toronto. The Wings won the best of five finals 3–2, and capped a sweep of Detroit team World Championships, crowning the town "City of Champions."

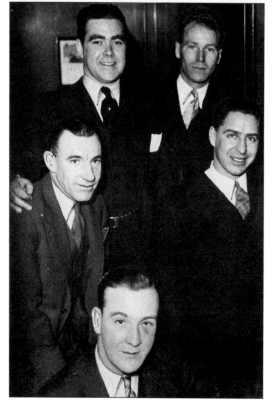

IN TO MEET THE BOSS, 1936. James D. Norris (top left) greets some of his Stanley Cup champion Red Wings shortly after their arrival in Detroit. Pictured clockwise from the bottom are Norm Smith (goalie), Doug Young (defense), James Norris Sr. (owner), Gordon Pettinger (center), and Johnny Sorrell (left wing).

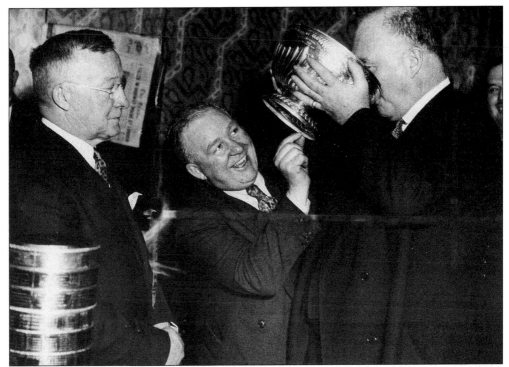

NO SWEETER DRINK AROUND, 1936. Red Wings owner James Norris Sr. takes a sip from the Stanley Cup as head coach Jack Adams tips it for him. Norris, a Chicago millionaire and a member of the famed amateur Winged Wheelers as a youth in Montreal, bought the club, Olympia Stadium, and the Detroit Olympics farm club for the bargain price of $100,000.

RED WING BROTHERS, 1937. Four sets of brothers face off against each other on the training squad in November 1937. From left to right (and from front to back) are as follows: Eddie and Bert Laprade, Wally and Hec Kilrea, Eddie and Mud Bruneteau, and Harvey and Archie Fraser. The Kilreas and Bruneteaus played in the NHL.

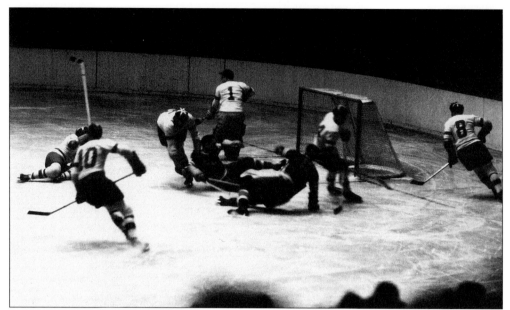

EARLY SEASON ACTION, 1936. Detroit goaltender Normie Smith (#1) steers the puck out of danger as the defense smothers the New York Rangers' attack. Left winger Don Deacon (#8) circles the boards to catch up to the play. Ebbie Goodfellow (#10) takes a shorter route to the blue line. Smith and the Wings shut out the Rangers 2–0.

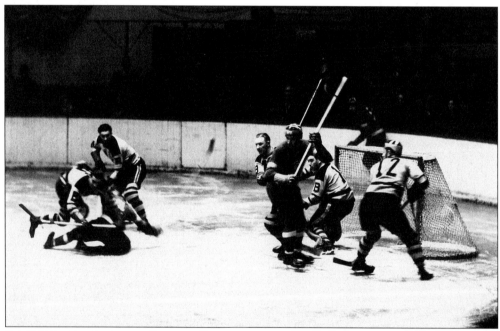

EN ROUTE TO ANOTHER LEAGUE CHAMPIONSHIP, 1936. Early season action against the visiting Boston Bruins sees the Red Wings triumph 4–3. The defending Stanley Cup champions would compile a 25–14–9 win-lose-tie record in the 48-game season to finish first in the American division.

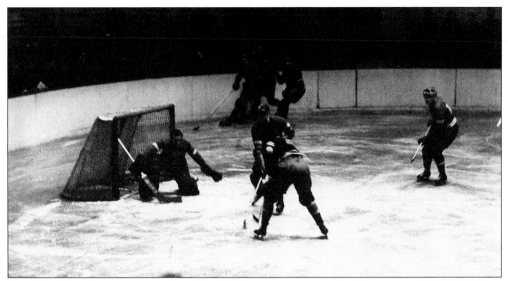

STANLEY CUP ACTION, 1937. April 8, 1937 saw game two at the Olympia, and the Red Wings knotted the series with a 4–2 victory. Here a Rangers forward attempts to deke the defense and shoot on Red Wings goaltender Earl Robertson. Robertson's only appearance for Detroit was in the 1937 playoffs. He was traded to the New York Americans that May.

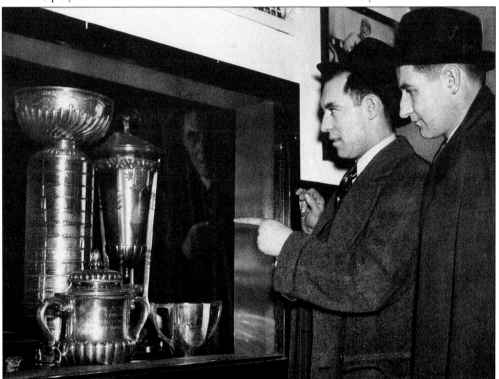

RED WINGS HARDWARE, 1938. Modere "Mud" Bruneteau (left) and Marty Barry admire hard-won trophies from the 1936–1937 campaign. The most recognizable is the Stanley Cup (background left) although it is thinner at this period in time. Detroit took the Cup in a best-of-five series, 3–2, over the New York Rangers.

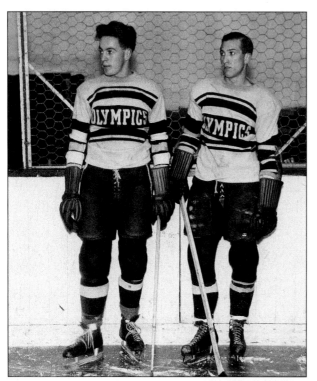

TWO RED WING HOPEFULS, 1938. Joe Carveth (left) and Les Douglas, pictured here as members of the Detroit Olympics, a Detroit farm club, both played their NHL rookie seasons as Wings in 1940–1941. Carveth played right wing and Douglas played center through the 1940s. Both would have productive playoffs for Detroit on the 1943 Stanley Cup wins.

LARRY AURIE, 1938. "Little Dempsey" played his entire 12-year NHL career with the Detroit franchise. At a height of 5'6" and weighing in at 148 pounds, he was Jack Adams's favorite player, and he gained the respect of his opponents with his aggressiveness, intelligence, and scoring touch. He was a right winger from Sudbury, Ontario, who led the league in goals with 23 in 1936–1937 and scored a total of 147 goals in his career.

"BLACK JACK" STEWART, 1938.
"Jack the Bouncer" Stewart, a 185-pound, 5'11" defenseman, played his rookie season for Detroit in 1938 and continued his service with the Wings until 1950, missing time for duty in the Royal Canadian Air Force during WW II. He was not an "out-of-town" fan favorite, and he often received boos from the first moment he stepped out on the ice. He was elected to the hall of fame in 1964.

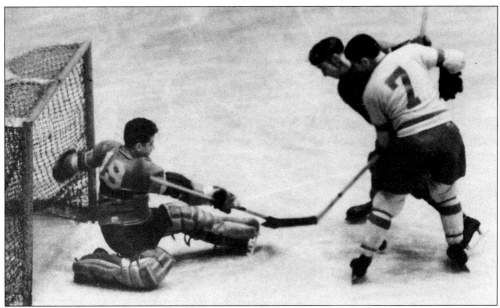

STANLEY CUP ACTION, 1939. The opening round of the 1939 Stanley Cup playoffs pitted the fifth-place Red Wings against the sixth-place Montreal Canadiens. Here, Montreal goalie Claude Bourque stops Detroit's Marty Barry (#7) during the second period of the third and deciding game at Olympia. Detroit won in overtime, and then lost to Toronto.

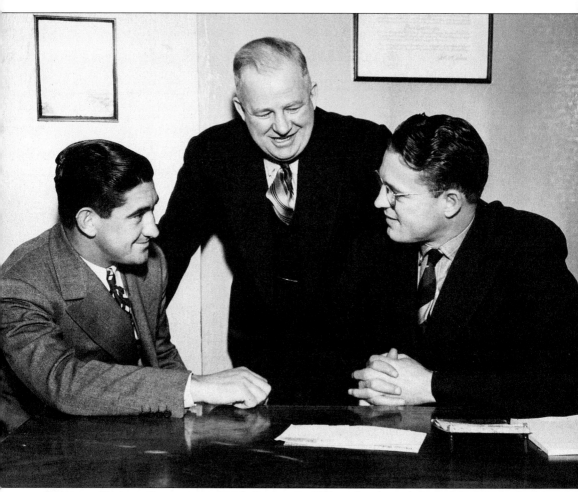

DETROIT, CITY OF CHAMPIONS, 1935. Detroit Red Wings head coach Jack Adams is flanked by Tigers manager Mickey Cochrane (left) and Lions head coach Dutch Clark (right) at a meeting of the minds. Each professional team captured their respective league championships and, in an unprecedented display of talent, went on to win their World Series titles. The Tigers beat the Chicago Cubs; the Lions went 7–3–2 and walloped the New York Giants 26–7 for their title; and the Red Wings shut out the Montreal Maroons 3–0 and defeated the Toronto Maple Leafs 3–1 to win the Stanley Cup.

Three

1940s

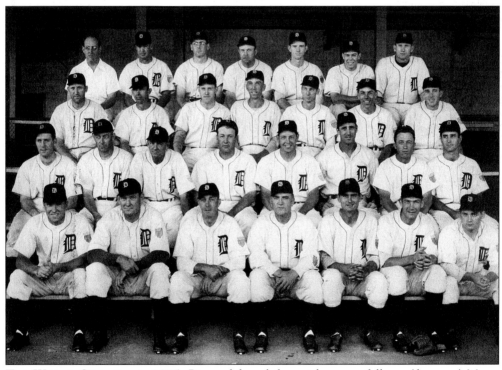

THE WORLD CHAMPIONS, 1945. Pictured from left to right are as follows: (first row) Mayo, Benton, Mills (coach), O'Neill (manager), Richards, Newhouser, and Overmire; (second row) Swift, Cramer, Walker, York, Cullenbine, Greenberg, Outlaw, and Hoover; (third row) Tobin, Hostetler, Kerris, Wilson, Webb, Maier, and Borom; (fourth row) Dr. Forsyth (trainer), Caster, Mueller, Miller, Eaton, Houtemann, and Trout. The team finished the season atop the American League with an 88–65 record in the last wartime season. In the World Series that one cynic predicted neither team could win, the Tigers beat the Chicago Cubs in seven games. Newhouser struck out 22 batters, winning two games and losing one.

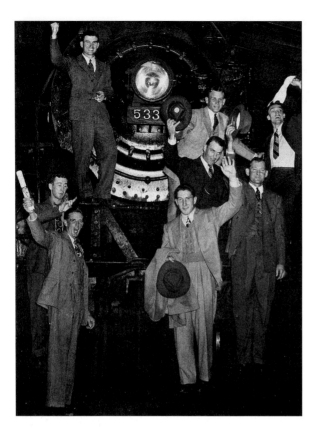

WORLD SERIES EXPRESS TRAIN, 1940. Some of the Tigers climb aboard the engine before pulling out for Cincinnati and the 1940 World Series. Pictured from left to right are as follows: (lower left) Tuck Stainback (outfield), Birdie Tebbetts (catcher), and Dutch Meyer (second base); (lower right) Fred Hutchinson, Archie McKain, Al Benton, Dizzy Trout, and Johnny Gorsica. All the men pictured in the lower right are pitchers.

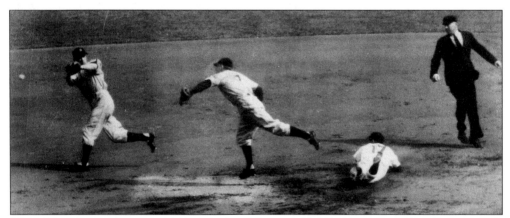

WILD THROW TO SECOND, 1940. Charlie Gehringer (far left) and Dick Bartell try to grab catcher Birdie Tebbetts's wild throw to second. Reds second baseman Eddie Joost gets back safely, then gets up and sprints to third. The Cincinnati Reds won game two by a 5–3 score that evened up the Series at one game apiece.

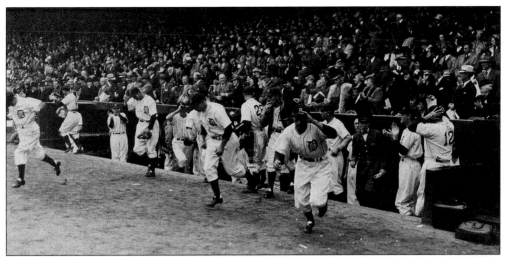

THE TIGERS BUST OUT, 1940. The Tigers charge out onto the field to start game three at Detroit after splitting the first two in Cincinnati. Tommy Bridges would strike out five, walk one, and surrender ten hits in his only start and complete game victory. Rudy York and Pinky Higgins would each hit a two-run home run in the seventh inning to settle the contest 7–4.

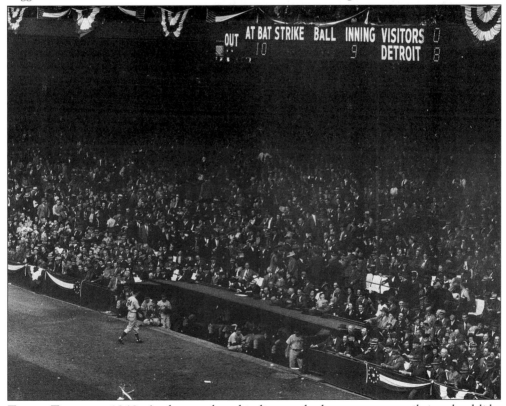

TIGERS TRIUMPH, 1940. As the scoreboard indicates, the home team prevails in a landslide, with a score of 8–0 in game five at Michigan and Trumbull. Tiger pitcher Bobo Newsom held the Reds to three singles as his teammates pounded out 13 hits to take a 3–2 lead in the best-of-seven series. Hank Greenberg belted a three-run home run to cap the scoring.

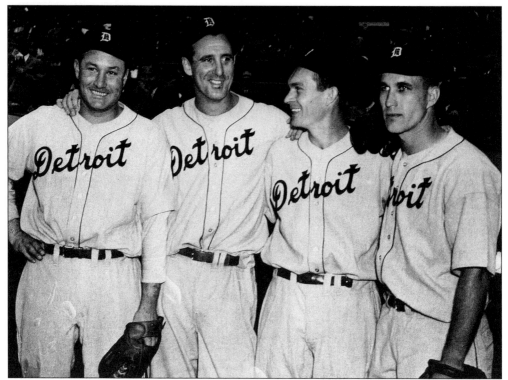

HAPPY TIGER TEAMMATES, 1940. Pictured from left to right are Rudy York, Hank Greenberg, Pinky Higgins, and Bruce Campbell—all smiles before game six in Cincinnati. The smiles would fade as the Bengals were blanked on five hits, losing 4–0. Reds pitcher Walters would contribute a home run to the victory. Detroit would lose the deciding seventh game by a 2–1 score.

OPENING DAY, 1941. The Detroit Tigers and Boston Red Sox form a column in front of the flagpole in centerfield to hear the National Anthem and start the 1941 baseball season. The defending American League champs hoped to earn another trip to the World Series, but their hopes were dashed. Just 19 games into the season, Hank Greenberg became the first American Leaguer to be drafted.

THE YOUNG SUPERSTAR, 1941. Joe Dimaggio leaps high into the air after a line drive in Briggs Stadium. In his fourth major league season, Dimaggio broke in with the New York Yankees after a successful minor league tour with the Pacific Coast League's San Francisco Seals. "Joltin' Joe" would hit safely in 56 consecutive games that season.

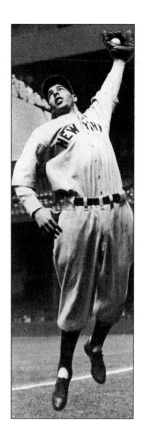

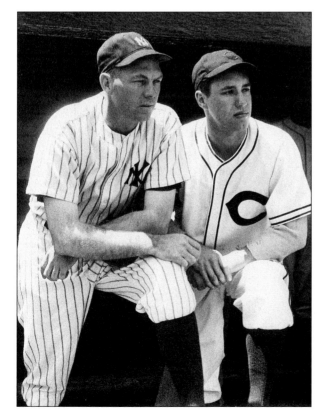

ALL-STAR STARTING BATTERY, 1941. The starting battery for the American League in the 1941 All-Star Game, held in Detroit for the first time, consisted of New York Yankee catcher Bill Dickey (left) and Cleveland Indians pitcher Bob Feller (right). The summer's finest moment came when the junior circuit won on a two-out, three-run homer by Ted Williams in the bottom of the ninth inning.

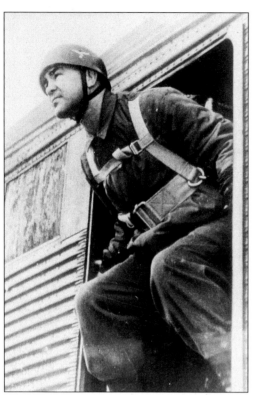

THE OTHER SIDE OF WAR, 1940. Former World Heavyweight champion Max Schmeling wound up a sergeant in his country's parachute forces; he is seen here preparing to make a practice jump. Max participated in the massive parachute drop on the island of Crete in 1940, where he was captured during the invasion. He always scoffed at the idea that he was a Nazi party member with political connections.

OFF TO WAR, 1942. The World Heavyweight boxing champion Joe Louis (second from right) is now known officially as Corporal Joseph Louis Barrow. He marches by the stables of the cavalry replacement center at Fort Riley, Kansas, with his fellow troopers. He served here briefly with baseball great Jackie Robinson; they both applied for Officer Candidate School.

EARLY PROFESSIONAL BASKETBALL, 1940.
The Detroit Eagles were a professional basketball team in the National Basketball League from 1939 to 1941. Bernie Opper was a member of the 1940 team that won the World Tournament, beating the Oshkosh All-Stars in the finals after upsetting the best all-Black clubs of the day, the New York Rens and the Harlem Globetrotters.

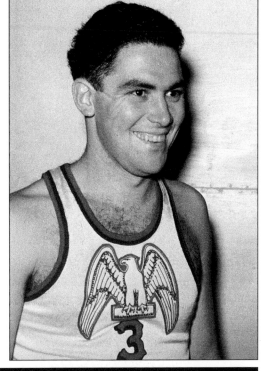

A DIFFERENT TYPE OF GLOVE, 1942. Red Wings head coach Jack Adams (left) shows boxer Charley Hayes how to hold a hockey stick in this wartime photograph. Assuming the pugilist could skate, one wonders if the league was so short of help that it would recruit from other professional sports.

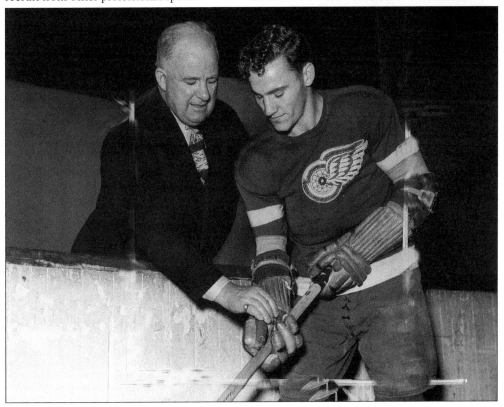

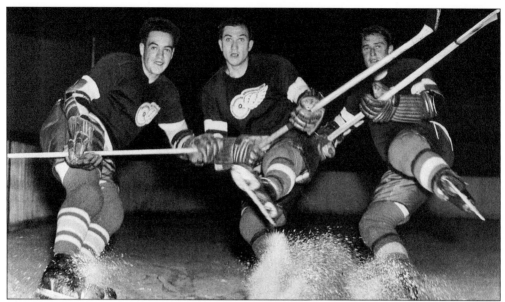

THE KID LINE, 1940. The Red Wings opened the 1940 season with their championship hopes resting on this rookie line made up of Joe Carveth (left), Les Douglas (center), and Archie Wilder (right). These three had successful minor league seasons in 1938–1939 and would help the team all the way to the Stanley Cup finals before losing to the Boston Bruins.

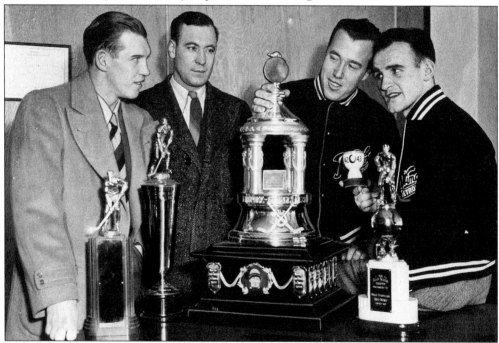

THE SPOILS OF VICTORY, 1942–1943. Pictured from left to right, Syd Howe, Mud Bruneteau, Johnny Mowers, and Cully Simon admire the fruits of their labor before starting the playoffs. Howe scored two goals and had four assists in a 12–5 drubbing of New York in November, and Mowers has his hand on the Vezina Trophy, which he won that year. The trophy seen on the far right is the Clem Alicia Trophy, which was given to the most popular Red Wing.

HARD SKATING WING, 1942.
Modere "Mud" Bruneteau, a hard-charging right wing, played his entire 11-year career with Detroit, beginning in 1935. He has a total of 139 goals, 35 of which he scored during the 1943–1944 season; he had led the team with 23 in the 1942–1943 season. In 1936, he ended hockey's longest game, scoring in the sixth overtime period.

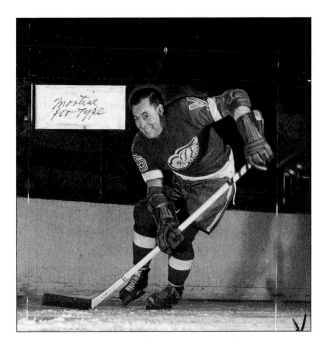

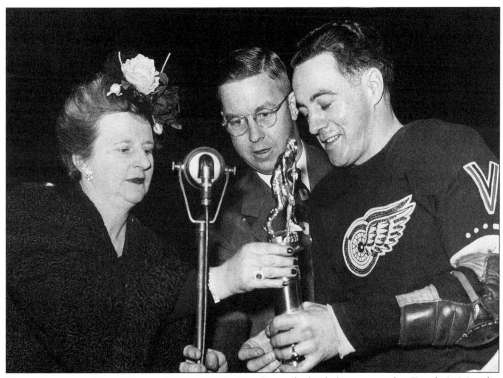

HIGH-SCORING RED WING, 1944–1945. Joe Carveth (right) accepts the Frank J. Murphy Memorial Trophy from Constance Murphy, while Don Waltric looks on. Named for the former lieutenant governor of Michigan, it was presented annually to the player scoring the most goals during the regular season. Carveth wears the "V-for-victory" patch on his jersey.

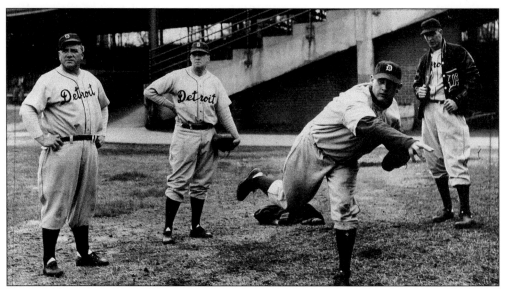

SPRING TRAINING, 1945. With manager Steve O'Neill (left) looking on, Paul "Dizzy" Trout demonstrates some of the finer points of pitching delivery to bullpen catcher Mills (left) and rookie pitcher Ruthstrom (right). The rookie wouldn't make the trip north, and Trout turned in an 18 and 15 win/loss season.

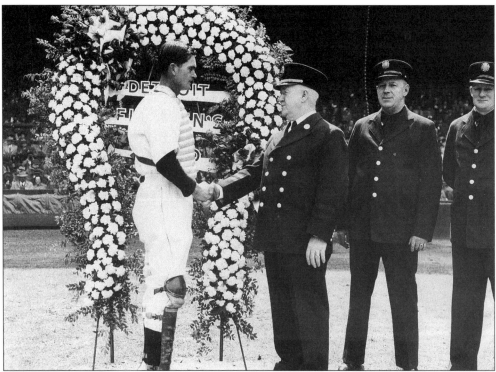

OPENING DAY, 1945. John Rourke, chief of the Detroit Fire Department, presents Tigers catcher Paul Richards with a giant horseshoe of flowers on behalf of the Detroit Fireman's Fund in April of the last wartime baseball season. Richards would share the catching duties with Bob Swift and post a .995 fielding average to go along with a .256 batting average.

HANK GREENBERG, 1945. Returning from four and one-half years of service in the U.S. Army on July 1, 1945, "Hammerin' Hank" hit .311 for the half season. In the final double-header of the year, needing one more win to clinch the pennant, Hank belted a season-ending, grand-slam home run in the ninth inning. The Tigers won 4–3 to move into World Series play.

SAFE AT THIRD, 1945. Tiger shortstop Joe Hoover slides in safely at third base to complete a double steal in the first inning against the Boston Red Sox. Third baseman Byron LaForest takes the peg too late as umpire Bill McGowan gets ready to make the call. Hoover platooned at shortstop with Skeeter Webb.

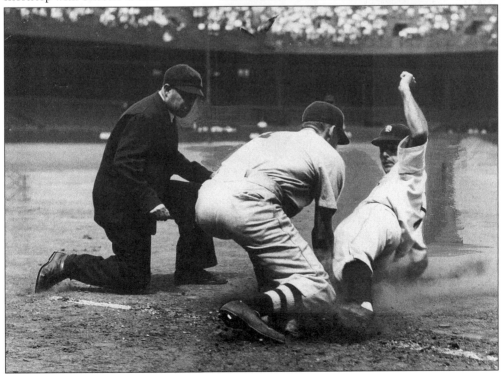

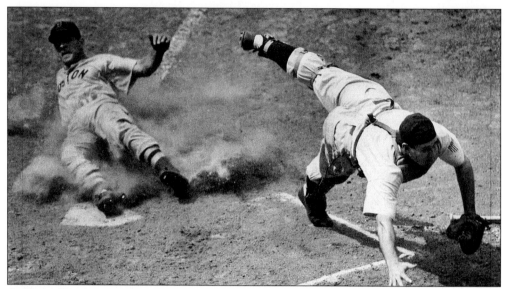

A WILD THROW HOME, 1945. Catcher Bob Swift makes a diving attempt to corral Dizzy Trout's errant throw home. Boston outfielder Johnny Lazor slides across safely as the pitcher's toss goes wild. Trout slipped while fielding a slow roller, then collided with the batter along the base line. He was not injured.

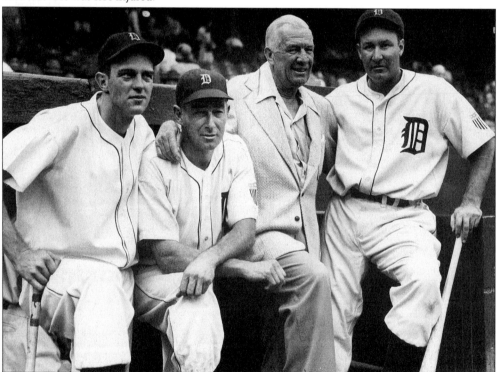

A HALL OF FAME VISIT, 1945. Hall of Fame great Tris Speaker visits the Tiger dugout during the last month of the season. Pictured from left to right are Dick Wakefield, Doc Cramer, Tris Speaker, and Rudy York. Speaker played for the Boston Red Sox and was a contemporary of Tigers great Ty Cobb.

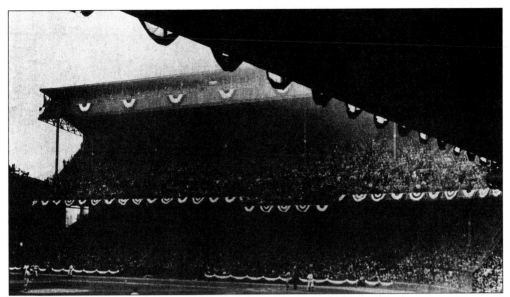

THE WORLD SERIES AT BRIGGS STADIUM, 1945. The yard is all decked out in red, white, and blue bunting for the first game of the 1945 World Series between the Detroit Tigers and their series nemesis, the Chicago Cubs. The house is packed to the rafters with rabid Detroit baseball fans, ready to see their team become champions.

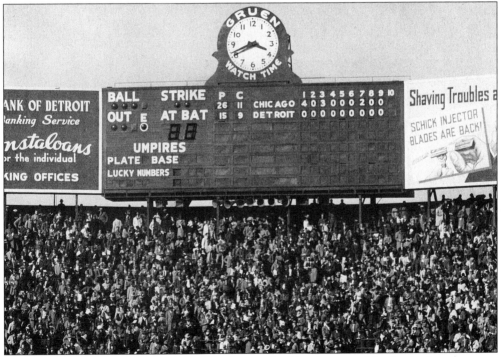

A BAD OUTING, GAME ONE, 1945. The fans in the bleachers stand in shock after game one ends in a Cubs runaway. Hal Newhouser gave up seven hits and eight runs in the first three innings, and the Cubs coasted to a 9–0 drubbing of the Bengals. The home team managed only six hits against Cubs pitcher Hank Borowy.

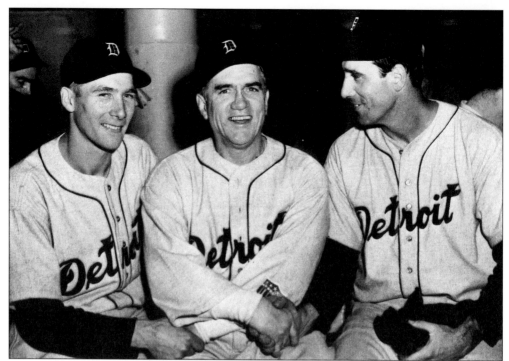

A GAME FIVE VICTORY, 1945. Manager Steve O'Neill congratulates Hal Newhouser (left) and Hank Greenberg (right), heroes of the game five victory at Wrigley Field. The Tigers beat the Cubs 8–4 to take a 3–2 lead in the Series as Newhouser struck out nine and Greenberg hit three doubles. Two Cubs errors helped pave the way.

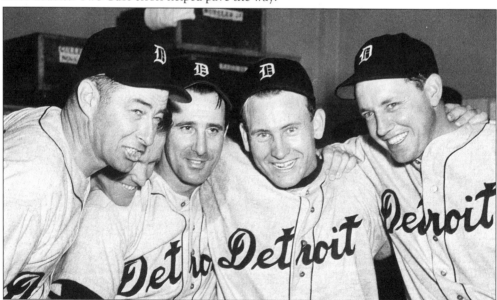

DIZZY WINS IN CHICAGO, 1945. Dizzy Trout (second from right) goes the distance, giving up one run and scattering five hits in the Tigers 4–1 victory in game four, which evened the Series at two games each. From left to right are Doc Cramer, Eddie Mayo, Hank Greenberg, Dizzy Trout, and Roy Cullenbine.

HANK PARKS ONE, 1945. Steve O'Neill welcomes Hank Greenberg around third base after he hit his first of two World Series homers. This one broke open the game in the fifth inning as two were on base. The Tigers evened the series at a game apiece with a 4–1 victory.

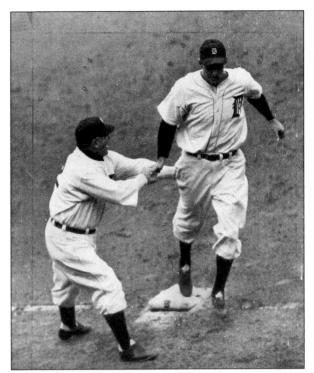

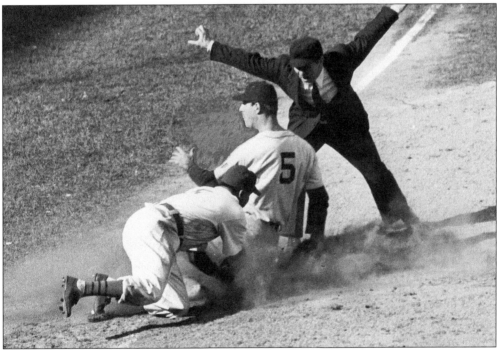

SAFE IS THE CALL, 1945. Hank Greenberg plows safely into third base on Ray Cullenbine's bunt. Cubs pitcher Paul Derringer throws too late to third baseman Stan Hack to get Hank, who had just doubled himself to second. Greenberg later scored on a deep drive to centerfield. The Tigers would go on to game seven with a 9–3 victory.

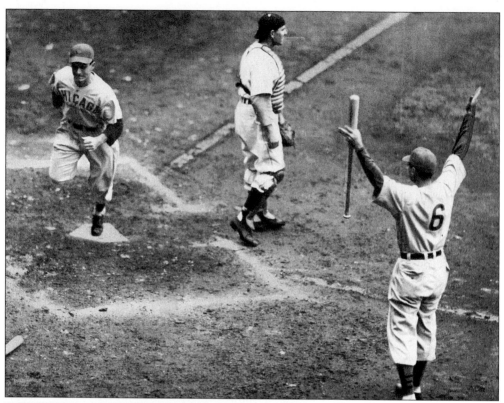

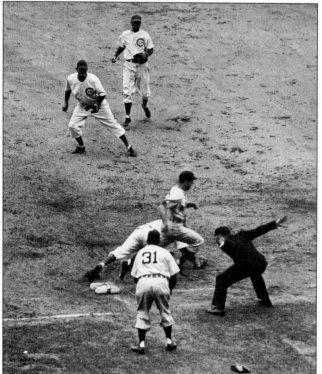

THE CUBS TAKE GAME THREE, 1945. "Peanuts" Lowrey scores the first run in the fourth inning of game three as Tiger catcher Bob Swift waits in vain for the throw from the outfield. Third baseman Stan Hack gives the coaching advice, and the Cubs go on to take a 2–1 series lead by blanking Detroit 3–0.

BEATING OUT A BUNT, 1945. Tiger third baseman Bobby Maier, pinch-hitting for Paul Richards, beats out an infield bunt in the sixth inning of game seven. Maier was the regular third baseman during the season but had only one plate appearance in the World Series. He had one at-bat and one hit for a 1.000 batting average.

REPORTERS GATHER AROUND, 1945. Members of the press gather at the locker of Tiger pitcher Hal Newhouser at the close of the 1945 World Series. Prince Hal led the majors with a 25–9 record and an ERA of 1.81 and won his second straight Most Valuable Player award. He won two games and lost one in the World Series, striking out 22 Cubs.

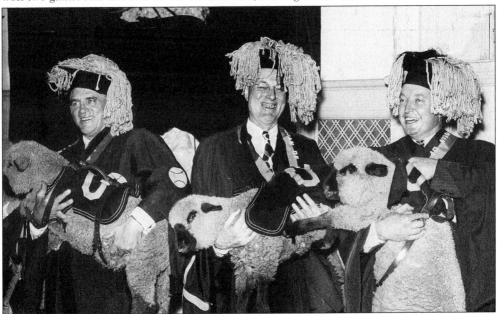

TIGER MANAGEMENT GRADUATES, 1945. Pictured from left to right are manager Steve O'Neill, general manager Jack Zeller, and vice president Walter "Spike" Briggs receiving their sheepskins and initiation into Detroit's mythical Linsdale University at a testimonial dinner held at the Book-Cadillac Hotel. This was the high spot of the World Series victory celebrations.

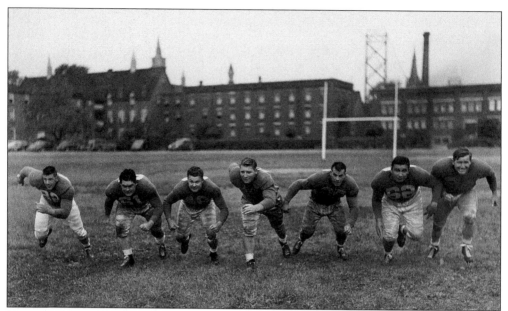

TRAINING CAMP, 1945. The Lions held training camp in 1945 at Assumption College in Windsor, Ontario, and with this core of linemen, won six of their first seven games. They dropped two of their last three, and ended up knocking themselves out of title contention. Detroit played on Thanksgiving Day for the first time since 1938 and lost to the Cleveland Rams with a score of 28–21.

THE FIRST NIGHT GAME, 1948. The first night game played by the Lions in Briggs Stadium saw them lose to Boston on October 9, 1948, with a score of 17–14. Detroit finished in last place for the third year in a row, their longest stay in the basement. Bob Mann and Mel Groomes joined the team that year and became the first African Americans to play for Detroit.

THE 18-YEAR-OLD ROOKIE, 1946. "Mr. Hockey" was introduced to Red Wings fans in 1946, with Jack Adams tagging him a "sure-fire" star. Gordon Howe appeared in 58 games in the 1946–1947 season, scoring seven goals and 15 assists for 22 points to go along with 52 penalty minutes served.

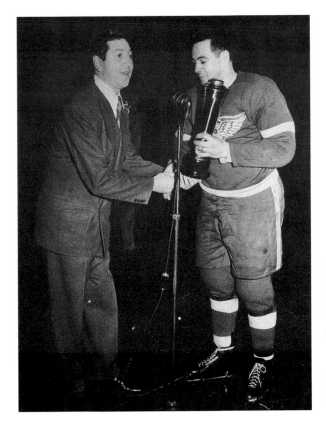

A RED WINGS TROPHY, 1946. Right Wing Joe Carveth accepts the Harry A. Gormley Trophy from a team official as the player who led the team in scoring for the season. Joe scored 17 goals and had 18 assists for 35 points during the 1945–1946 season. The award was first given in 1941 and was later named the Bruce A. Norris Trophy.

73

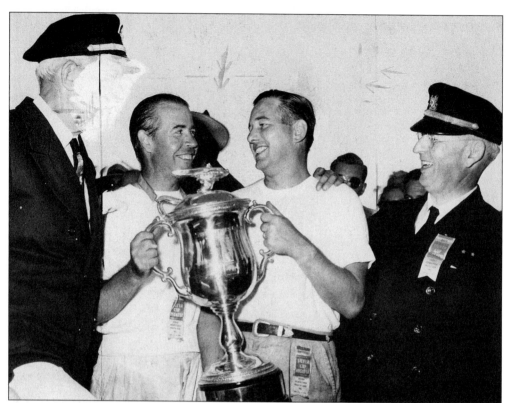

A HARD-WON TROPHY, 1948. Danny Arena takes the Fageol Trophy as the winner of the Silver Cup program on the Detroit River in September 1948. Just one week before, he suffered disappointment during the Gold Cup Race when his boat, *Such Crust*, split in half and sank.

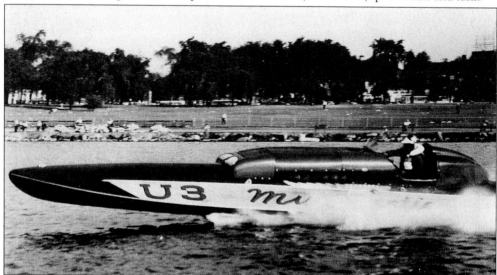

THE FASTEST BOAT, 1949. My *Sweetie*, driven by Bill Cantrell, earned the distinction of becoming the first boat-and-driver combination as the fastest Gold Cup qualifiers with a mark of 92.4 mph. This marked the first year that qualification speed trials were written into the rules.

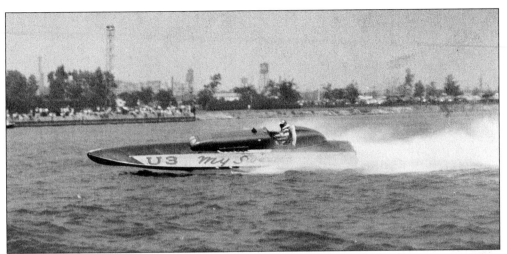

GOLD CUP WINNER, 1949. Bill Cantrell and *My Sweetie*, a two-step, Allison-powered boat designed by John Hacker, turned in a new 3-mile Gold Cup heat record of 78.6 mph. This was just a few years after a speed over 70 mph was considered almost impossible.

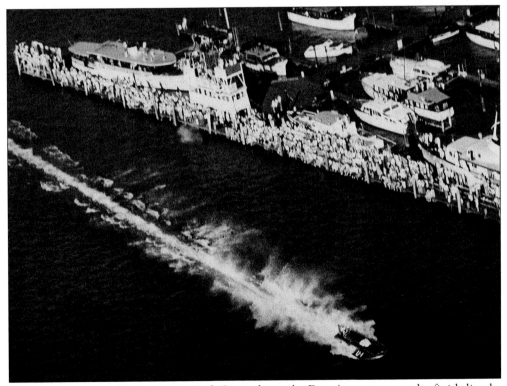

THE HARMSWORTH RACE, 1949. *Such Crust*, driven by Dan Arena, crosses the finish line by the Detroit Yacht Club as the winner of the first heat of the 1949 Harmsworth Trophy Race. Owned by Jack Schafer (of the bread-baking family), this boat and *Such Crust II* were fan favorites in this race and the Gold Cup races.

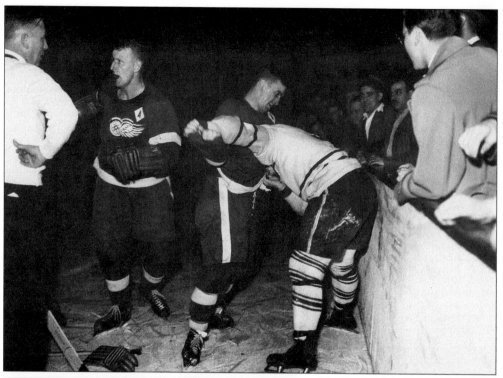

UP-CLOSE ACTION, 1949.
"Terrible Ted" Lindsay enforces
the law in a late-season game in
the 1949 campaign while a
teammate makes sure there is no
other interference. The referee
waits patiently to dole out
penalties, and these fans are very
close to the action. It wouldn't
take much to help, as nothing
separates the spectators and
players but the boards.

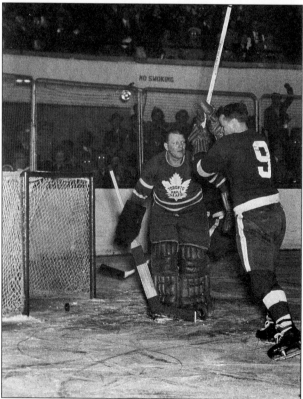

HE SCORES! 1949. Gordie Howe
assumed this position over 800
times in his long and legendary
career. Here he beats Toronto's
Turk Broda with the game's only
goal to end the semi-final playoffs
and send the Red Wings off to
play the New York Rangers for
the Stanley Cup. Howe recorded
35 goals in the 1949–1950
season.

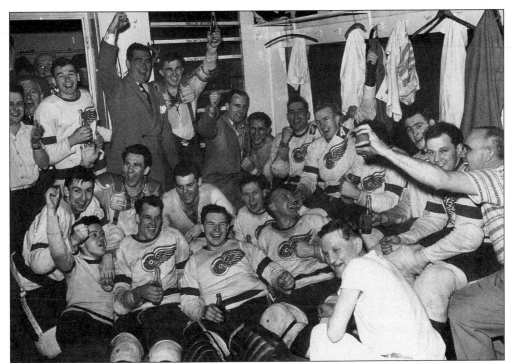

JUBILANT DRESSING ROOM, 1949. The Detroit Red Wings celebrate their semi-final victory over the Montreal Canadiens in April 1949, with Coca-colas and Vernor's ginger ale. They have just won the best of seven series 4 games to 3 and must now face the Toronto Maple Leafs in the finals. Detroit won the league title with a 34–19–7 record to top the six-team league.

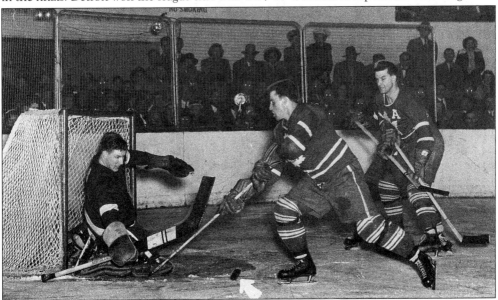

STANLEY CUP FINALS, 1949. Game two action at Olympia sees Detroit goalie Harry Lumley stop the puck on a two on one breakaway by the Toronto Maple Leafs. Bill Ezinicki takes the shot while Harry Watson trails the play, looking for a rebound. The Maple Leafs won the game with a 3–1 score.

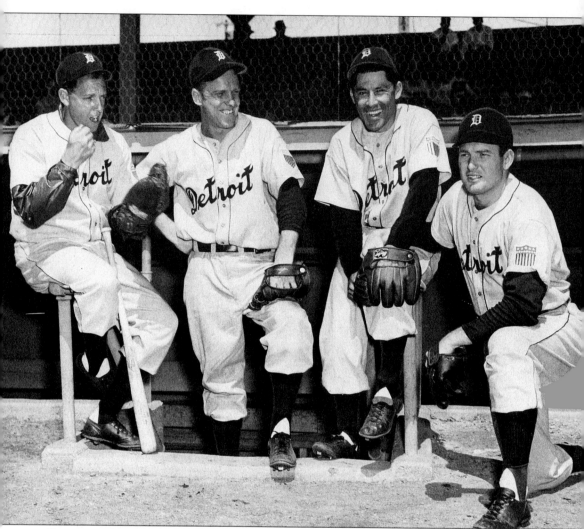

DYNAMITE INFIELD, 1947. Pictured from left to right are Roy Cullenbine (first base), Eddie Mayo (second base), Eddie Lake (shortstop), and George Kell (third base). These team members make up the infield crew that the Tiger management hopes will take them back to the top of the league. Having sold Hank Greenberg to Pittsburgh (without the courtesy of telling him first), the team called upon Cullenbine to replace him at first base. He responded by hitting 24 home runs and drew a team record of 137 walks. George Kell was the only Tiger to hit .300, and Eddie Lake led the team in errors with 43; the team could only finish second, 12 games behind the Yankees.

Four

1950s

THE CORNER AT NIGHT, 1950. The Queen of Diamonds wears her best night finery in this scene during the 1950 season. Night baseball was still new in Detroit; the first game played under the lights took place in June 1948. Fans flocked to see their team play—day or night—and this season, the team would ring up 95 victories, their most in 16 years. They had a continuous, but tenuous, hold on first place from June to September and were tied with New York late in the month. The Cleveland Indians became the spoilers, sweeping the Tigers three straight in Cleveland. The team finished second (again), three games out.

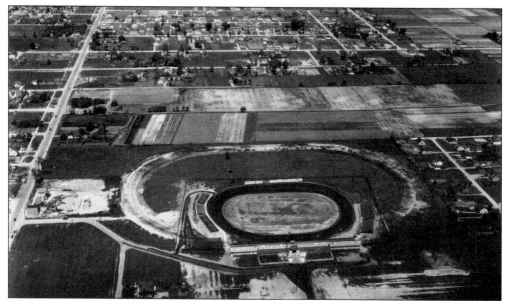

THE PLACE TO BE, 1950. This aerial shot shows Motor City Speedway, all spruced up with a new facade and more grandstands at each turn and along the "home stretch." Located at 8 Mile Road and Schoenherr, it became the place to race as the sport entered its boom years after World War II.

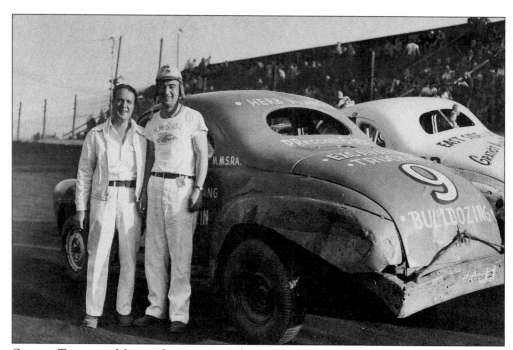

ON THE TRACK AT MOTOR CITY, 1951. Felix Brooks (right) stands next to his sponsor on the track at the beginning of the 1951 racing season. Brooks, the former secretary-treasurer of the Michigan Modified Stock Racing Association, surprised everyone by winning his first feature race in his 1950 Oldsmobile (#9), a sportsman-class car.

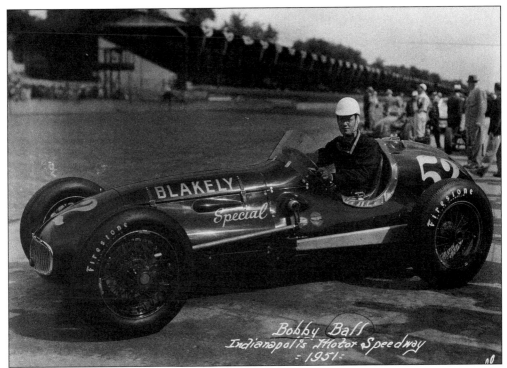

AN INDY CAR, 1951. Driver Bobby Ball poses in the cockpit of his Blakely Special on the infield at Indianapolis in 1951. This is a beautiful example of the type of race cars that were in use in the Midwest during the growing years of auto racing.

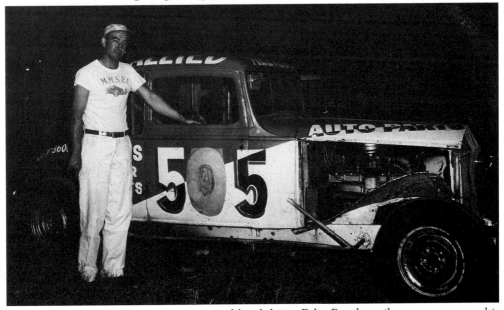

IN THE PITS, 1950s. Native Detroiter and local driver Felix Brooks strikes a pose next to his modified stock car in the pits at Motor City Speedway. Stock car races at the Motor City, Mount Clemens, and Flat Rock tracks would often attract fans and drivers from as far away as Toledo.

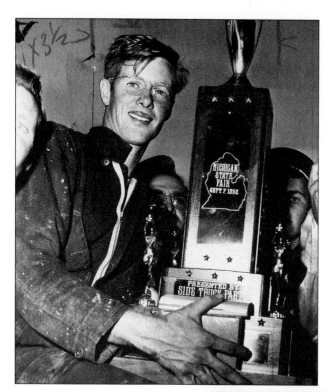

THE STATE FAIR WINNER, 1952. Indy driver Bobby Ball holds the trophy he won at the Michigan State Fair on September 7, 1952. By the looks of it, it is a sizeable award. The race at the Michigan State Fair was a rather grueling one—it was 250 miles in length.

THE GOVERNOR'S RACE, 1952. Seen here on the starters stand at Motor City Speedway, Michigan Gov. G. Mennan "Soapy" Williams presents the trophy to Felix Brooks, winner of the 1952 Governor Williams Trophy Race. Brooks won the 1951 hard-top stock car championship and would finish the 1952 season as the runner up.

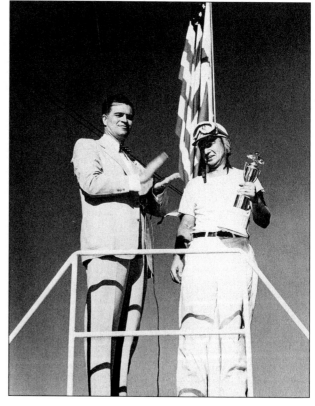

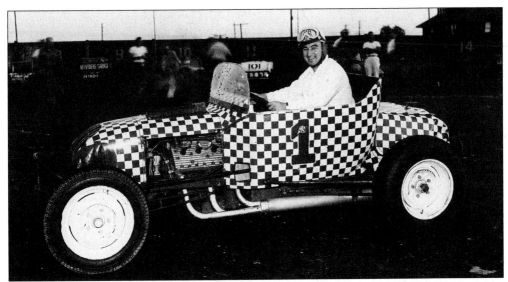

MIDGET RACERS, 1953. One of three different types of car entries for racing in Michigan was the midget car, which, like its 1935 counterpart, had to be a certain size and length to qualify. Usually, every Sunday program at Motor City Speedway featured a midget race as part of the preliminary races leading up to the feature.

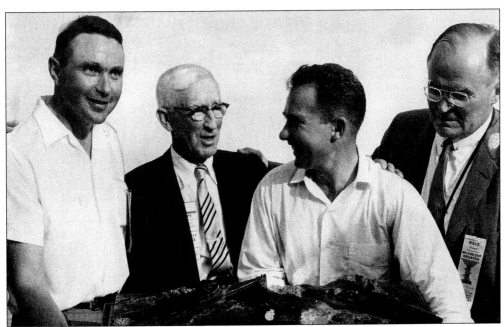

WHAT IT'S ALL ABOUT, 1950s. Gar Wood is surrounded by race officials who pose with him and his Harmsworth Trophy—an award the British never could take back from him. The elaborate bronze prize features two antique boats on a heavy sea and is mounted on a mahogany base. During WW I, the trophy was nearly destroyed in a zeppelin raid on London. The base was lost to fire and was replaced by Wood with the mahogany from his *Miss America I.*

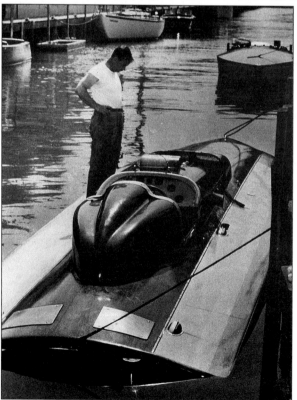

HYDROPLANE HARDWARE, 1950S.
Here is one of the prettier river rats, posing with the various American Power Boat Association trophies that were the quest of both drivers and owners. The smaller trophies are for the different classes of powerboats and the different regattas. The T.O.C. Free for All was held as part of both the Gold and Silver Cup Regattas as a sprint race. The tall trophy in the middle is a River Rougue Boat Club prize.

TROUBLE AT THE DOCK, 1950.
Driver Bill Cantrell stares into the engine compartment of *My Sweetie* as the team faces more trouble. In 1948, the boat led the pack for six laps, then had trouble with the hull; in 1949, Cantrell and his team won the race; in 1950, the Gold Cup was won by a team from Seattle, Washington. The winning team also won the right to sponsor the event the next year.

GAME FACES, 1950. Detroit's Ted Lindsay broke into the clear for an open shot on net until Toronto's Bill Borilko introduced him to the lumber and rode him into the boards during semi-final action at Maple Leaf Garden. The intensity of the Detroit-Toronto rivalry is quite evident by the look on each player's face.

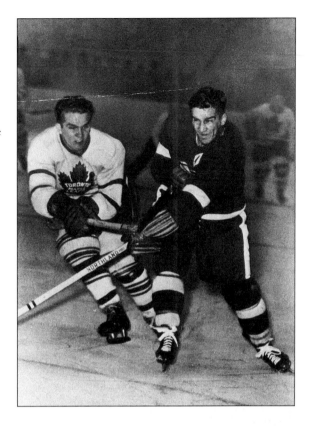

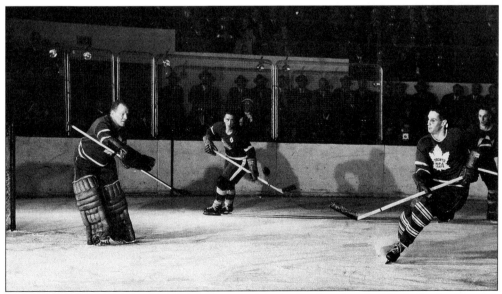

STANLEY CUP SEMI-FINALS, 1950. Toronto Maple Leaf goaltender Turk Broda directs a rebound toward teammate defenseman Jim Thomson (right front) as Ted Lindsay watches. The Wings finished first during the regular season and defeated Toronto in their best-of-seven semi-finals 4 games to 3.

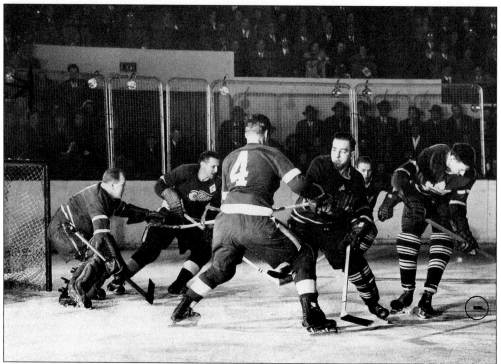

RED WINGS SWARM THE NET, 1950. Game five of the 1950 semi-finals action sees the Leaf defense stymie the Detroit attack. John McCormack (right) moves to clear the puck as the Wings are held in check by Turk Broda in net, Bill Juzda (fourth from left), and Bill Barilko (background). Captain Sid Abel and defenseman Red Kelly (#4) are foiled.

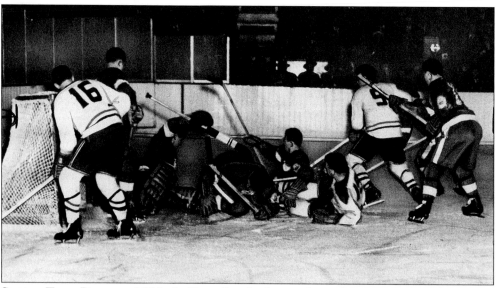

STINGY TEAM DEFENSE, 1951. As Terry Sawchuck sprawls on the ice in front of the Detroit net, his teammates come to his aid. Bob Goldham takes his place in net, Marcel Pronovost and Marty Pavelich are on the ice, and Jimmy Peters and George Gee stay on their feet. The Red Wings swept the playoffs, winning eight games straight.

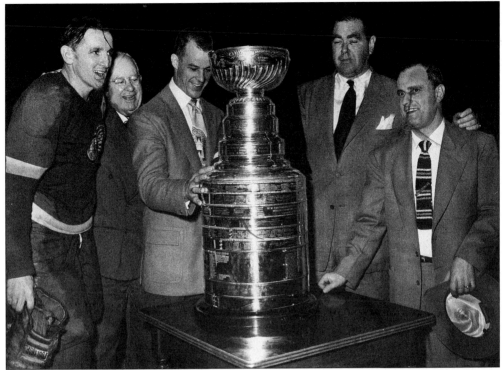

ANOTHER STANLEY CUP, 1950. Pictured from left to right are Sid Abel, Jack Adams, Gordie Howe, Jim Norris Jr., and Tommy Ivan as they admire hockey's holy grail, the Stanley Cup. Detroit defeated the Maple Leafs in a hard-fought, seven game semi-final and the New York Rangers in another seven to take their fourth Stanley Cup.

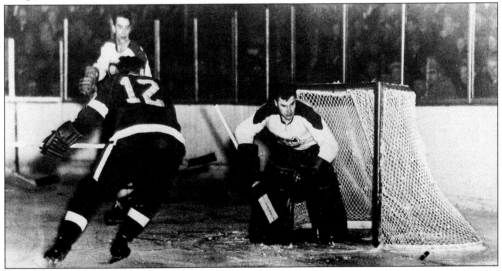

PLAYOFF ACTION, 1951. Detroit claimed its third straight league championship for the 1950–1951 season and faced the Montreal Canadiens in the first round of the playoffs. With the Canadiens up 2–1, Detroit put on an offensive show in game four. Here Sid Abel (#12) takes a shot at goalie Gerry McNeil in the second period. Detroit knotted the series with a 4–1 victory.

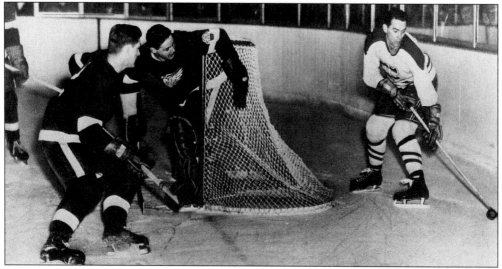

DO OR DIE: GAME SIX, 1951. Defenseman Red Kelly (left) assists Terry Sawchuck in defending the net against former Wing Bert Olmstead (with the puck). After losing game five at home 5–2, the Red Wings were facing elimination in this game six. In the midst of a seven-straight title run, these Wings were ousted from the playoffs 3–2.

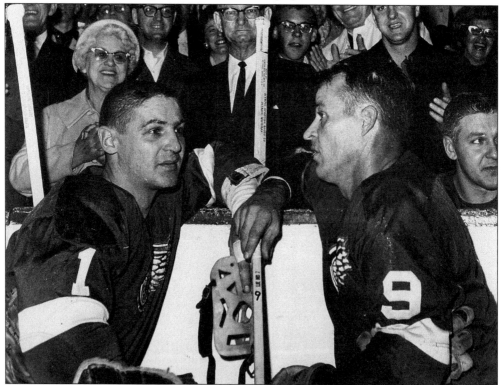

TWO WING LEGENDS, 1950S. Goalie Terry Sawchuck (left) and Gordie Howe kneel by the boards during warm-ups to discuss strategy during the team's dominance of the NHL in the 1950s. The Red Wings would win seven out of eight league titles, six of them consecutively, and four Stanley Cups during that reign.

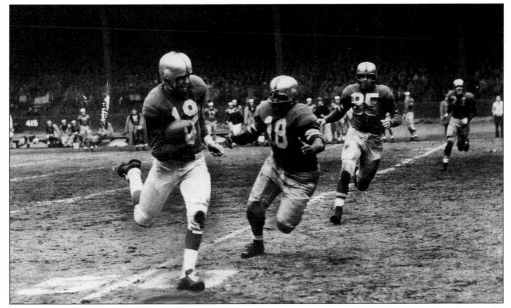

THANKSGIVING DAY, 1951. Jack Christiansen, in his role as punt returner, ran back two for touchdowns in the 52–35 romp over Green Bay on November 22, 1951. He set a team record against Los Angeles in October, returning two punts for touchdowns and repeated the feat against the Packers; he executed an 89-yard return, which is the second longest in team history.

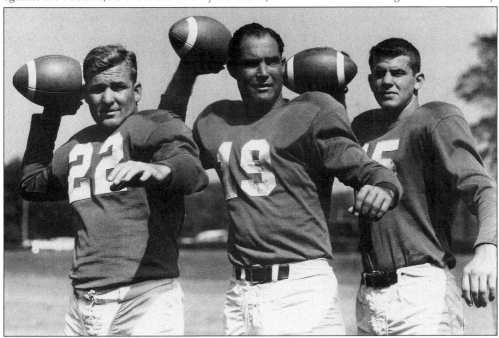

A TRIO OF QUARTERBACKS, 1952. Pictured from left to right are Bobby Layne, Tom Dublinski, and Jim Hardy, all set to lead the Detroit Lions to victory. Although Hardy was used sparingly, Dublinski would often spell Bobby Layne at the quarterback spot. The Lions lost two of their first three games (both to the San Francisco 49ers), then won eight of their last nine to earn a playoff spot against Los Angeles.

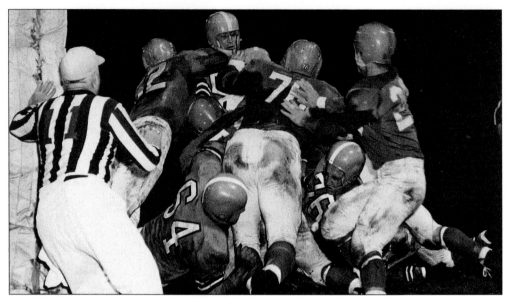

A GOAL LINE STAND, 1952. The Lions defense holds against the offensive might of the Cleveland Browns in the NFL championship game played in Ohio three days after Christmas. The defense had four such stands in this game, which the Lions won 17–7 to win its first title in 17 seasons.

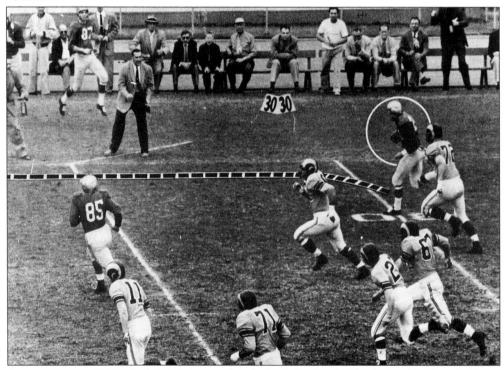

INTERCEPTION, 1953. Jack Christiansen (circled), defensive halfback for the Detroit Lions, races down the sidelines for a 92-yard interception touchdown against the Los Angeles Rams. Detroit had two losses this season, both to the Rams, but in this case they came from behind to win 37–24, in front of a record crowd of 93,751 at Los Angeles.

THE OLD STRAIGHT-ARM, 1953. Lions halfback Bob Hoernschemeyer gives a graphic lesson of how to use an old football weapon—the straight arm. Baltimore Colts Bert Rechichar is removed from his path as he sprints 49 yards for a touchdown. Bob became the first Lion to lead the team in rushing for four consecutive seasons, from 1950 to 1953.

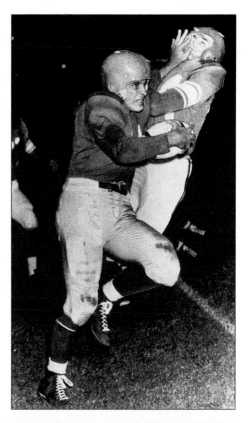

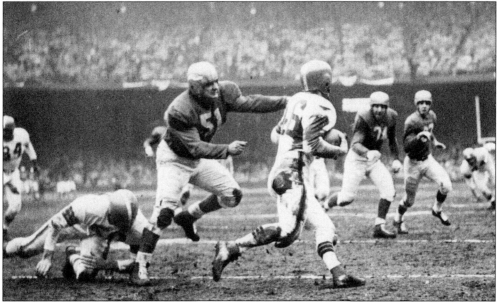

NFL TITLE GAME, 1953. The first NFL championship ever played at Michigan and Trumbull saw the Lions and the Browns battle to a 10–10 tie after three quarters. Here, Vince Banonis draws a bead on the Cleveland ball carrier in a tough defensive struggle. The Browns were playing in their eighth straight championship game.

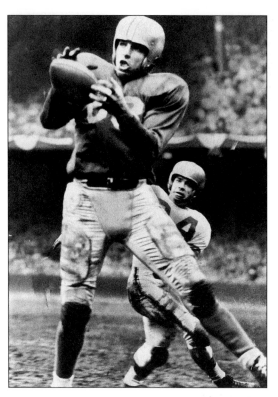

DORAN GRABS THE WINNER, 1953. Filling in for the injured Leon Hart, defensive end Jim Doran catches a Bobby Layne pass that was good for a 33-yard touchdown, tying the score at 16. He broke loose behind the Browns halfback Ken Konz for the score. Doak Walker's place kick gave Detroit a 17–16 lead.

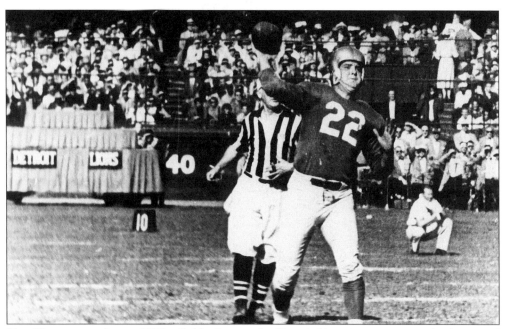

THE HEART OF A LION, 1950s. Bobby Layne, the Detroit Lions greatest quarterback, arrived in the Motor City in 1950 after one year with the Bears and another with the New York Bulldogs. The stories surrounding this Texas stalwart are legion, but he led his team to dominance in the 1950s, capturing four league titles and three championships in eight seasons.

THE LIONS ARE TRIUMPHANT, 1953. Head coach Buddy Parker is carried off the Briggs Stadium field by Joe Schmidt, Torgy Torgeson, and Yale Lary after Detroit beat Cleveland 17–16 to claim the 1953 championship. It was the club's second straight title, and with the Chicago Bears and Philadelphia Eagles, the Lions were only the third team to win back-to-back titles. The Lions posted a 10–2–0 record with the defense intercepting a team record of 38 passes.

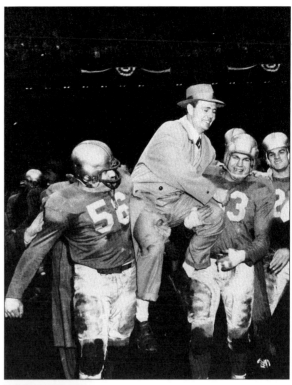

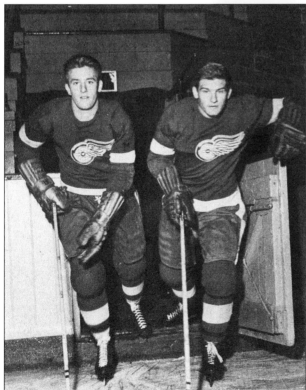

BROTHER RED WINGS, 1950. Larry and Johnny Wilson take the ice in their rookie season with Detroit. Before leaving the Motor City, Larry, a centerman, would play three seasons; Johnny, a left winger, would play seven. They played on four Stanley Cup-winning teams as the Red Wings entered their decade of dominance of the NHL.

93

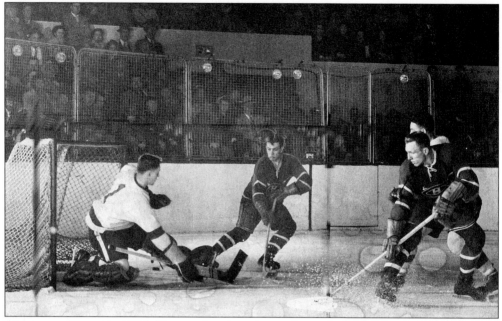

MONTREAL DENIED, 1952. Outnumbered at the goal mouth, Red Wings goaltender Terry Sawchuck denies the Canadiens access to his net in the third game of the 1952 Stanley Cup Finals at Olympia. Detroit had claimed its third straight league title with a 44–14–12 record. The Red Wings swept the Toronto Maple Leafs in four straight games and would do the same to these Canadiens.

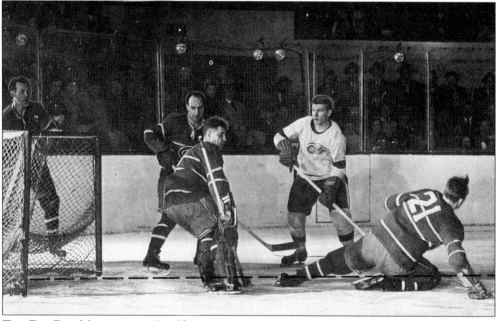

THE BIG RED MACHINE, 1952. Slipping past Montreal goaltender Gerry McNeil is the puck and the last hope of stalling the Red Wings hockey machine. Metro Prystai took the shot for the first of two goals and an assist in this fourth game of the finals. Johnny Wilson watches the shot go in as Montreal's Jim MacPherson (#21) lunges in vain.

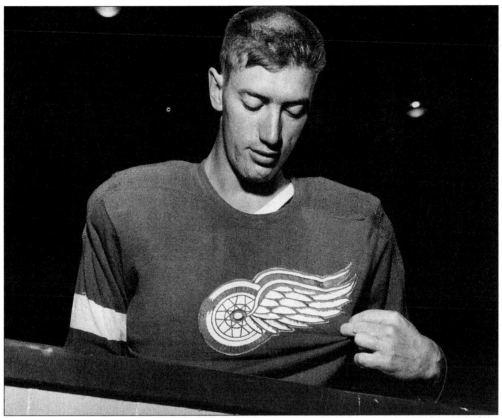

ROOKIE SEASON, 1953. Al "Radar" Arbour looks good wearing the winged wheel to start his rookie season. Al would be claimed by the Chicago Black Hawks in the 1958 intra-league draft and spend the next 14 seasons in uniform. He would become a head coach and a hall-of-fame member.

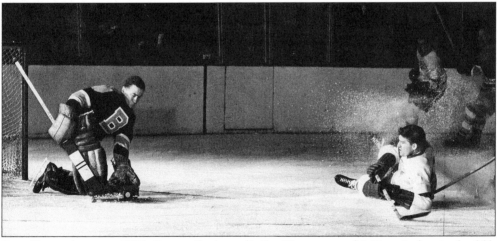

SEMI-FINAL ACTION, 1953. Boston Bruin goalie Jim Henry stops this Detroit shot in the fifth game of the 1953 semi-finals at Olympia. Detroit would win this game by a 6–4 score for their second win in five games but would lose the sixth and deciding game at Boston Garden three nights later.

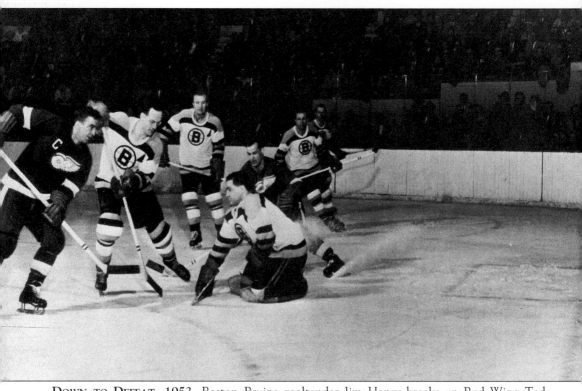

DOWN TO DEFEAT, 1953. Boston Bruins goaltender Jim Henry breaks up Red Wing Ted Lindsay's scoring bid during the 1953 semi-finals. After blanking Boston in game one 7–0, Detroit could only manage one more victory as the Bruins won the series 4–2. In this decade of dominance, from 1949 to 1959, the Wings would be perennial Stanley Cup contenders; they made a habit of winning two consecutive Cups, then losing, then winning two more. In 1953, the Montreal Canadiens won the Cup, defeating the Bruins in the best of seven series, 4 games to 1.

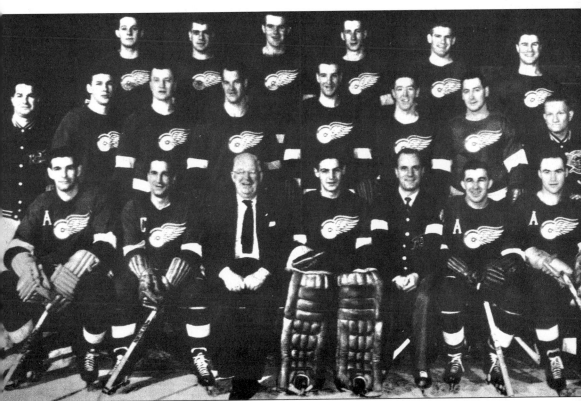

STANLEY CUP CHAMPIONS, 1953–1954. Team members are pictured from left to right as follows: (front row) Bob Goldham, Ted Lindsay, Jack Adams, Terry Sawchuck, Tommy Ivan, Marty Pavelich, and Red Kelly; (middle row) Lefty Wilson, Alex Delvecchio, Benny Woit, Gordie Howe, Glen Skov, Marcel Pronovost, Jimmy Peters, and Carl Mattson; (back row) Dutch Reibel, Metro Prystai, Jim Hay, Bill Dineen, Johnny Wilson, and Tony Leswick. Detroit won its fourth Stanley Cup in six years in 1954, defeating the Maple Leafs in four straight games and the Canadiens 4–3 in the finals. Goaltender Terry Sawchuck recorded a goals-against average of 1.67, and Gordie Howe added four goals to secure the victory.

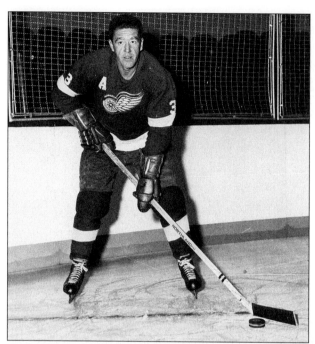

PREMIERE DEFENSEMAN, 1950S.
Detroit Red Wing Marcel
Pronovost came to the Motor
City from the Omaha club in
time to play in the 1950 playoffs.
He stayed on the blue line at
Olympia until May 20, 1965,
when he was traded to Toronto
as part of an eight-man swap. He
would play on five Stanley Cup-
winning teams.

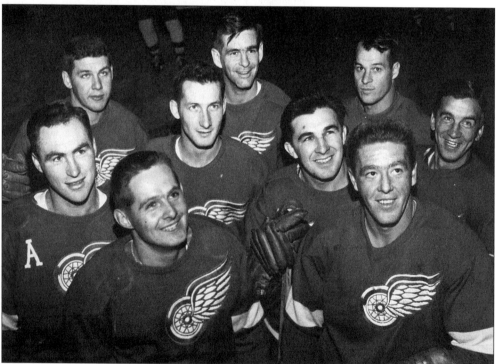

HAPPY RED WINGS, 1955. All smiles after successfully defending the Stanley Cup during the
1954–1955 season, are the following team members from left to right: (front row) Alex
Delvecchio and Dutch Reibel; (middle row) Red Kelly, Bob Goldham, Marty Pavelich, and
Ted Lindsay; (back row) Bill Dineen, Marcel Pronovost, and Gordie Howe. They defeated the
Montreal Canadiens in the best-of-seven series final with a score of 4–3 to repeat as champions.

FIRST QUARTER ACTION, 1954. Detroit Lions linebacker Joe Schmidt intercepts an Otto Graham pass with Jim David (#25) back to help. This resulted in Doak Walker's field goal and the first score of the day. It was but one bright spot in an otherwise disastrous day as the Lions bid to become the first three-peat champions was destroyed.

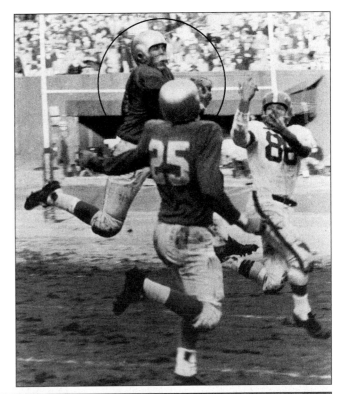

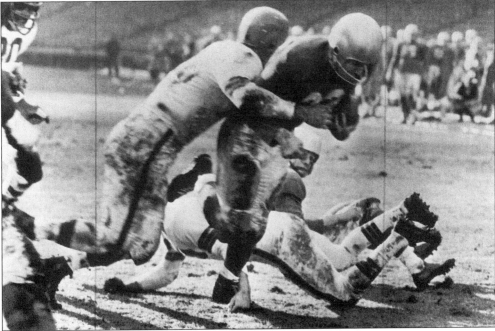

ALL WRAPPED UP, 1954. Lions quarterback Bobby Layne is wrapped up by the Cleveland defenders early in the 1954 title game. He managed to get his offense running in the second quarter, but only one drive resulted in a score, with Bill Bowman scoring from 5 yards out. At that point, the score was 21–10, in favor of the Browns.

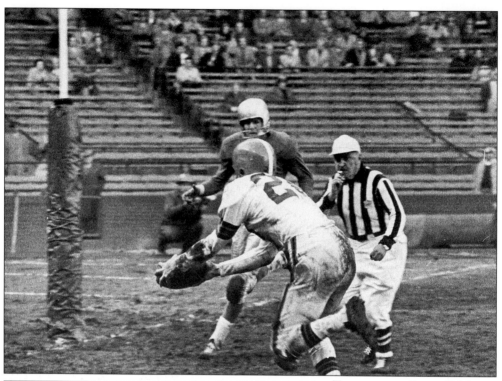

TOUCHDOWN PASS, 1954. Cleveland Browns end Ray Renfro snags a touchdown pass from Otto Graham as Lions back Robert Lee Smith looks on helplessly. This 37-yard toss put Cleveland up 7–3 in the first quarter after Doak Walker's "first-blood" field goal from 36 yards out.

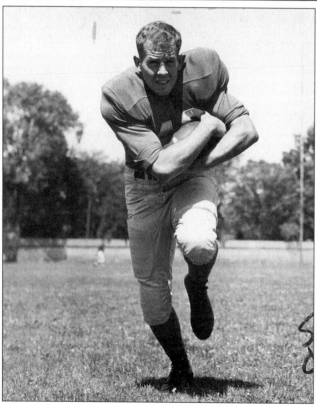

ROOKIE FULLBACK, 1954. Bill Bowman, a rookie Lion in 1954, returned a kick-off 100 yards for a touchdown in the Lions opening-game victory over the Chicago Bears on September 26, 1954. It happened to be his first game as a Lion. The team lost him to military service prior to the start of the 1955 season.

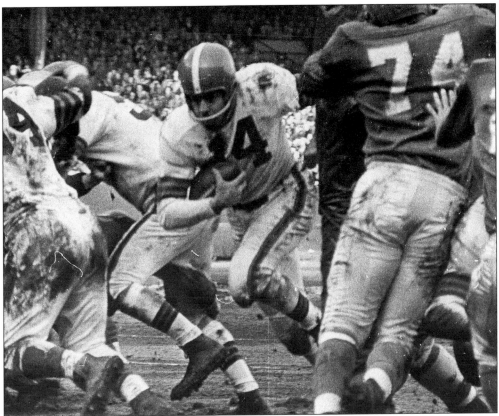

GRAHAM SCORES AGAIN, 1954. Detroit defensive tackle Bob Miller (#74) slams into the goal post as Otto Graham slams into the end zone on a one-yard quarterback keeper, trouncing Detroit with three rushing and three passing touchdowns. Graham had not thrown a scoring pass against the Lions all season.

CLEVELAND QUARTERBACK SCORES ANOTHER, 1954. Cleveland Browns quarterback Otto Graham rushes for his third touchdown of the day as Lions defensive back Carl Karilivacz (#21) misses his tackle. Lions coach Buddy Parker said that it was nearly impossible to win three times in this league. He was right.

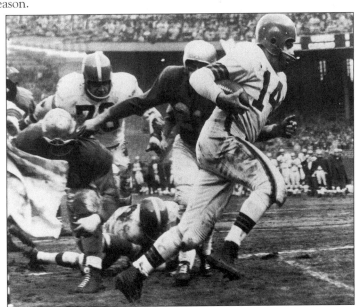

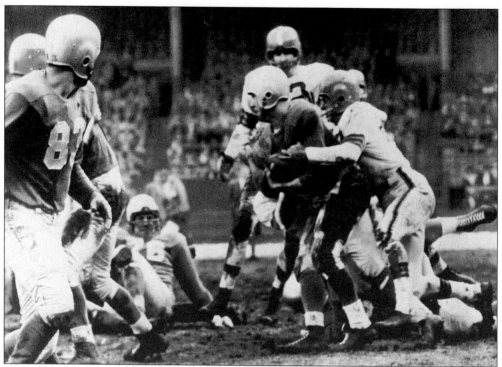

NOWHERE TO GO, 1954. Bobby Layne and the Lions offense looks like it is standing still; it was for the greater part of the game. Layne was completely baffled by the Cleveland defense, whose constant pressure caused him to throw six interceptions. When back-up quarterback Dublinski was inserted in the third quarter, the Browns destroyed him too.

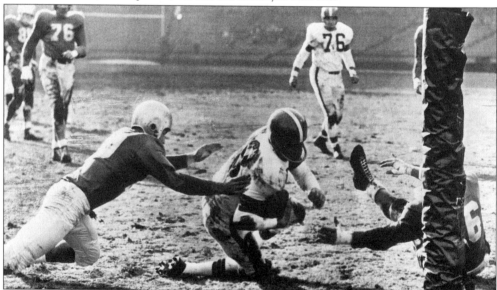

A BROWNS TOUCHDOWN, 1954. Lions halfback Bill Stits (left) and linebacker Joe Schmidt (behind goal post) can't stop the Cleveland Browns end Darrell Brewster from scoring on a short pass into the end zone. Defensive tackle Lou Creekmore (#76) looks on in dismay. The Lions lost several veterans to retirement and Yale Lary to the military.

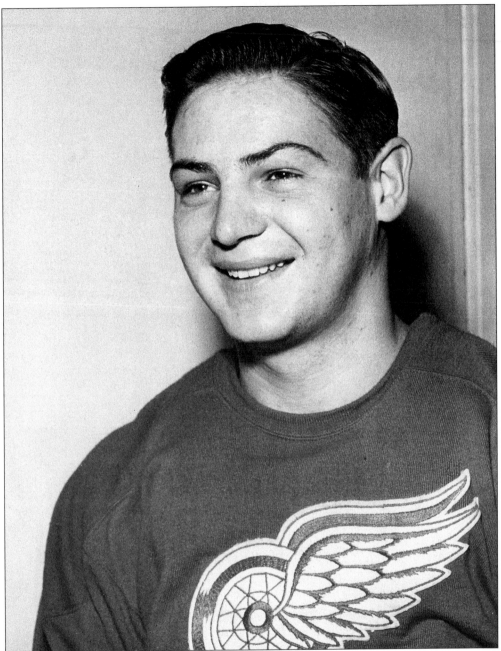

THE NET MASTER, 1957. Hall-of-fame goaltender Terry Sawchuck began his NHL career with Detroit in 1949 and minded the nets for 21 seasons. He played 57,205 minutes, appeared in 971 games, allowed 2,401 goals, and recorded 103 shutouts, all of which are NHL records for goal tenders. He was the first player to win rookie-of-the-year awards in three different professional leagues, including the NHL in 1950–1951. Terry led the league in shutouts three times and won the Vezina Trophy four times. His playoff goals-against average was 2.41, and he registered an incredible 0.63 in an eight-game sweep in 1952. Terry died tragically at the age of 40.

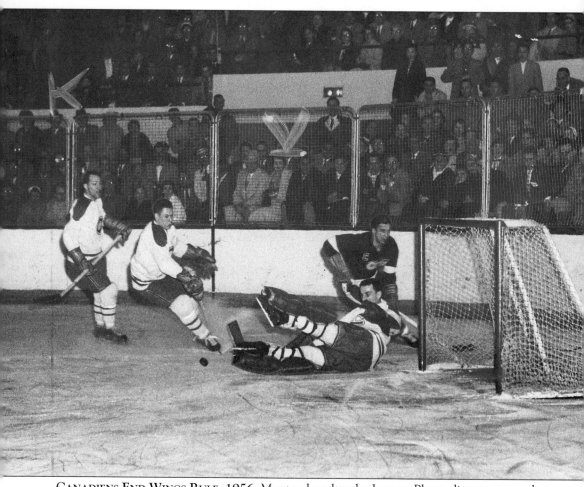

CANADIENS END WINGS RULE, 1956. Montreal goaltender Jacques Plante dives to stop a shot from Red Wings captain Ted Lindsay during the fifth game of the Stanley Cup Finals. The Wings were down 3–1 and were on the brink of elimination when the Canadiens put them away with a 3–1 victory at the Montreal Forum. They won the Stanley Cup best-of-seven series 4–2. Their capture of the league title interrupted the Wings consecutive streak of seven straight. This was the first of five straight Stanley Cups, a feat not yet repeated.

HOME-MADE STOCK CAR, 1955. Driver Dan Oldenberg sits in his modified Buick Century convertible, which he would race on the weekends (and some week nights). This season he won four feature races. The car looks pretty much as it did when it left the factory, so most of the modification must be under the hood.

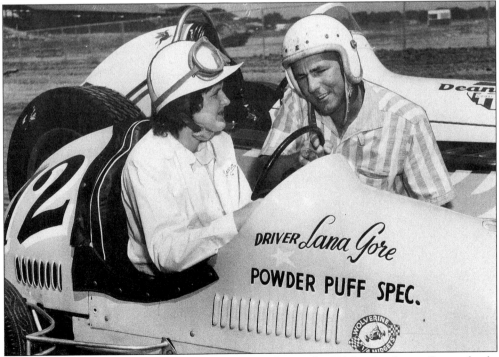

THE POWDER PUFF SPECIAL, 1957. Third-place Indianapolis 500 finisher Jimmy Bryan checks out Lana Gore in her undersized midget car that she drove as a hobby. In the background is a standard-size racer. Jimmy Bryan was in Detroit to compete in the 100-mile, big-car race that was to take place at the fairgrounds on Labor Day.

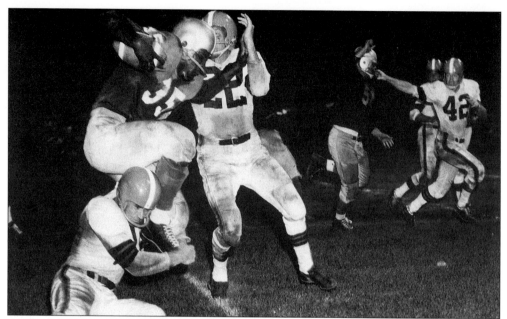

A TIMELY TRADE, 1957. The Lions traded fullback Bill Bowman and defensive tackle Bill Stits to the San Francisco 49ers for fullback John Henry Johnson, seen here grabbing a third quarter pass in an exhibition game against Cleveland. Johnson rushed for 621 yards and five touchdowns in 1957 to spark the Lions to an 8–4–0 record, winning first place. They would meet Cleveland for the title.

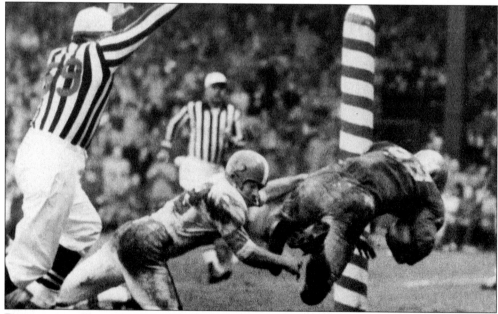

DIVING FOR A TOUCHDOWN, 1957. Detroit Lions end Steve Junker dives into the end zone for a score in the third quarter of the 1957 NFL title game in Detroit against Cleveland. Junker scored on a 23-yard pass from quarterback Tobin Rote, who replaced the injured Bobby Layne late in the season. Rote guided the team to a 59–14 victory, tossing four touchdowns to avenge the 1954 blowout.

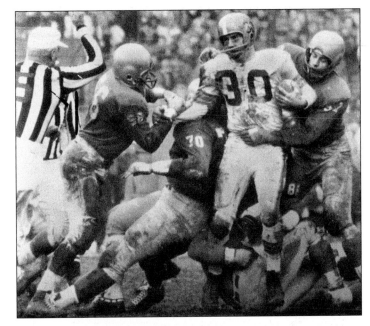

OUTSTANDING DEFENSE, 1957. Joe Schmidt (#56) leads the Lions defensive corps against the Browns in the title rematch game in 1957. With the memory of the 56–10 shellacking still fresh in their minds, the Schmidt-led defense intercepted five passes and recovered two fumbles in the game.

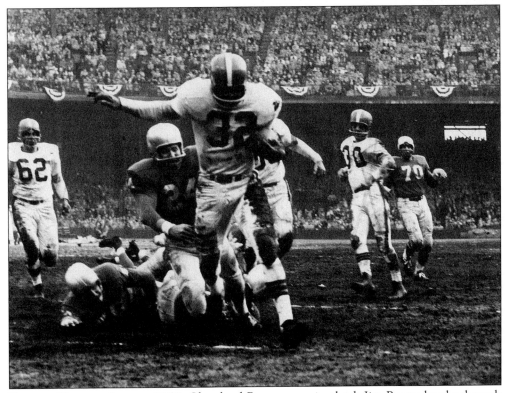

FUTURE HALL-OF-FAMER, 1957. Cleveland Browns running back Jim Brown breaks through the Lions' defense and shows his heels to Jack Christiansen (#24) on this 30-yard jaunt in the second quarter for the Browns' first touchdown. Jim Brown would go on to become the NFL's all-time leading rusher.

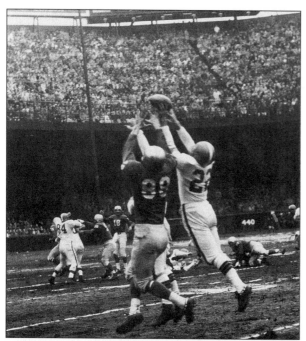

JUST "JUNK," 1957. Lions receiver Steve Junker (#88) is frustrated on this pass play by the Cleveland Browns defenders Ken Konz and Galen Fiss (partially hidden behind Junker). The unsuccessful toss was from quarterback Tobin Rote (#18) in the first quarter. The Lions won 20–7 and would meet the Browns for the championship.

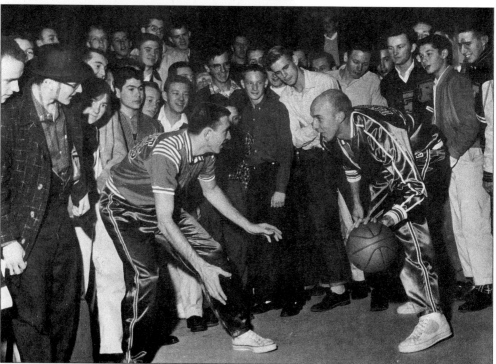

A PISTON'S CLINIC, 1957. Gene Shue (left) demonstrates his defensive skills against George Yardley (right) in a short clinic for fans before a game during their inaugural season in Detroit. Yardley was one of the game's first stars and a jump-shot pioneer. One of six holdovers from the Fort Wayne Pistons, "The Bird" Yardley became the first NBA player to score 2,000 points in a season.

SWING AND A MISS, 1957. Ed Conlin of the Detroit Pistons gets free for a lay up as Phil Rollins of the Cincinnati Royals swipes at the ball and misses. Conlin was traded from Syracuse for Piston favorite George Yardley and could not repeat his offensive statistics from the previous year.

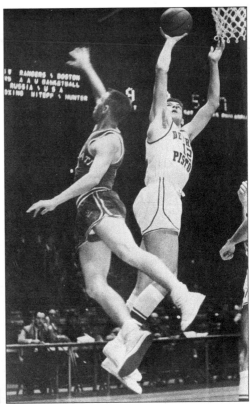

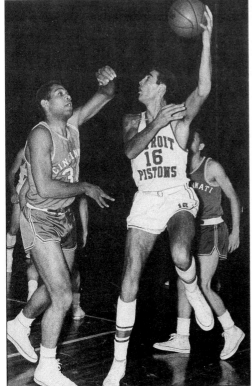

A MOTOR CITY HOOK SHOT, 1958. Detroit Pistons forward Phil Jordan (#16) looks and hooks high over Cincinnati's Wayne Embry for the field goal. Jordan played two seasons for the Pistons, averaging 12 points and 7 rebounds per game. The Pistons finished their second season in Detroit, in third place, in the Western Division.

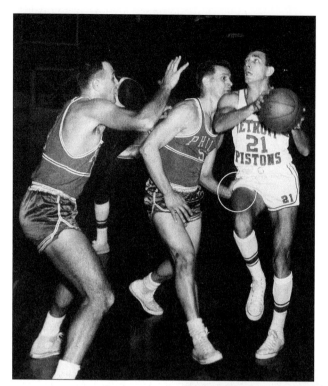

A HELPING HAND, 1958. Hot-shot Piston guard Gene Shue gets a helping hand he doesn't need in this game against the Philadelphia Warriors. The finest pre-Bing Piston guard, Shue led the team in scoring twice and finished second in his three other Detroit seasons. Olympia announcers would boom out the plaudit, "Twoooo for Shuuuue!!"

BIG STRETCH FOR A LITTLE MAN, 1958. "Tricky Dick" McGuire (#15), the Pistons point guard, snares a rebound against the Boston Celtics' Jim Loscutoff (#18) as Lou Tsioropoulas (#20) and the Pistons Walter Dukes (right) look on in a game at Olympia. Dukes, a lanky, 7-foot center, patrolled the middle for the Pistons first six years in Detroit. He led the NBA in fouls with 311 and 332 in the 1957–1958 and 1958–1959 seasons.

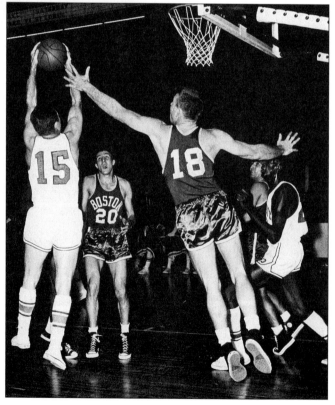

A LITTLE RUNNING ADVICE, 1958. Los Angeles Laker Bob Leonard shouts advice to Pistons point guard Dick McGuire in an early 1958 game at Olympia. One of the 1950s outstanding playmakers (he was every bit Bob Cousey's equal), McGuire was acquired in a trade with New York and finished second in league assists with 454 in 1957 and 1958. He had his best point total, 655, in the 1958–1959 season.

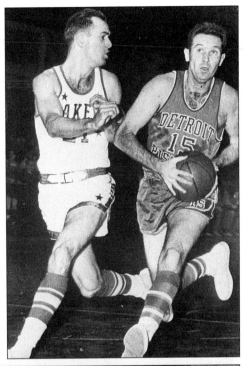

COACHES TIME OUT, 1958. Pistons coach Red Rocha is on the ball during a practice at West Branch. Playing a 72-game schedule that year, the team had a losing record. They won 28 and and dropped 44, finishing 21 games behind St. Louis. They were defeated by Minneapolis in the Western Division semi-finals.

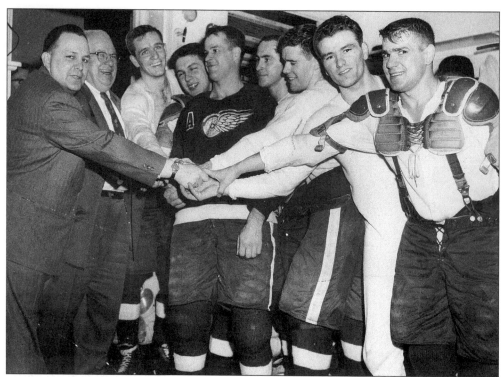

ALL FOR ONE, 1957. Alternate captain Gordie Howe stands amidst his teammates as they prepare for playoff action against the Boston Bruins. Detroit had taken its seventh league title in eight years, compiling a 38–20–12 record in the six-team circuit. The team would split the first two games at home, then lose the next three.

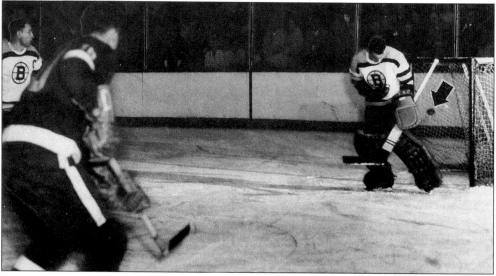

INTO THE NET, 1957. Center Alex Delvecchio (left front) scores the Red Wings' first goal in the seventh game of their playoffs against the Boston Bruins. Goalie Don Simmons appears handcuffed by the shot as it gets by him and into the net. Detroit lost this crucial game and was ousted from the playoffs.

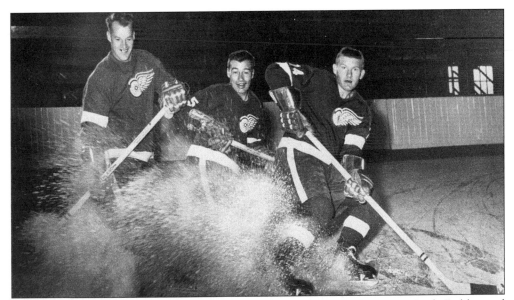

A NEW PRODUCTION LINE, 1957. Pictured from left to right, Gordie Howe, Guyle Fielder, and Johnny Wilson form head coach Jimmy Skinner's new model production line at the start of the 1957–1958 season. The team would finish the season in third place and lose to the Montreal Canadiens in four straight. Fielder played in two games before being sent to the minors.

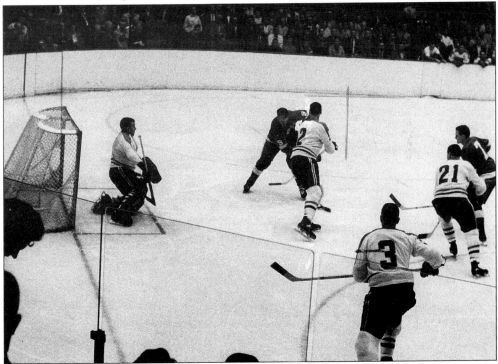

ACTION AGAINST MONTREAL, 1950S. Gordie Howe prepares to send a backhand shot to the net against the Canadiens. Goaltender Gump Worsley prepares to stop the shot as the defenseman is too late. The two teams were always in contention throughout the decade and would usually wind up facing each other in the Stanley Cup Finals.

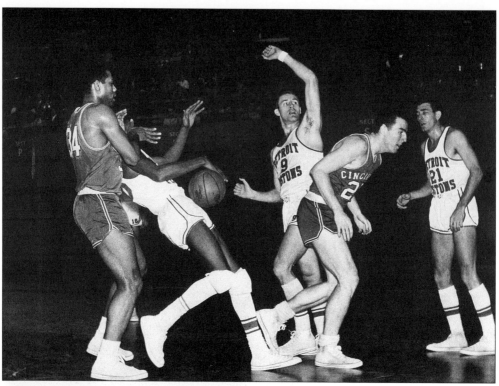

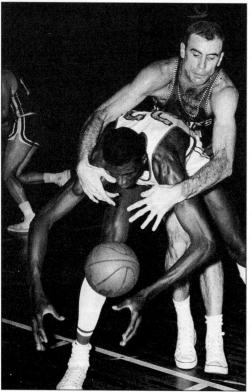

A HEADLESS PISTON, 1959. Forward Shellie McMillon appears to have lost his head in this game against Cincinnati, and Bill Thieben (#9) seems to be looking for it. McMillon served four years with Detroit after graduating from Bradley. He averaged 8.5 points per game and amassed 1,267 rebounds over that period.

OVER THE BACK FOUL, 1959. St. Louis Hawks forward Bob Pettit checks center Walter Dukes from behind in a game on the hardwood at Olympia. The Pistons would soon change venues; in 1961, they would move into a new home at the Cobo Hall convention center, which had 10,939 seats.

UP WITH THE LAKERS, 1959.
Earl Lloyd goes up with the Lakers to try to block this one-handed jumper as Walter Dukes (left) and Gene Shue (right) look on. Lloyd would provide steady play off the bench, contributing just under nine points per game and over 320 rebounds for the season.

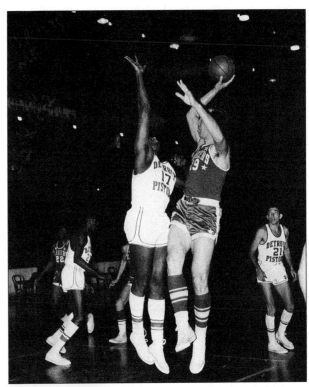

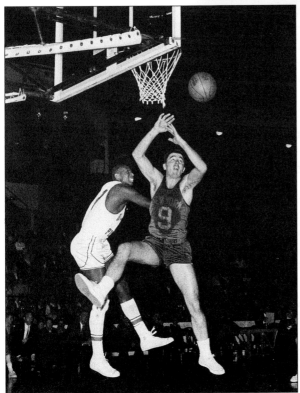

A NIGHT AT THE BALL, 1959.
Piston forward Earl Lloyd and New York Knicks Richie Guerin have at the ball in a game at Olympia. Veteran forward Lloyd and role-playing Dick Farley were vital additions to the club in 1958. Earl Lloyd was acquired from the Syracuse Nets, and on October 31, 1950, he became the first African American to play in the NBA.

115

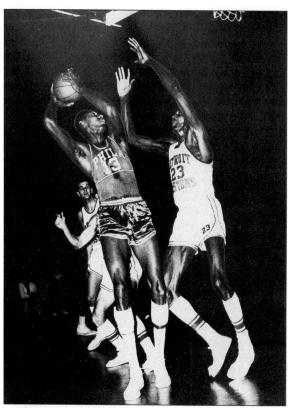

A TOWER OF POWER, 1959. Pistons center Walter Dukes towers over this Philadelphia Warrior as the way to the basket appears blocked. Acquired from Minneapolis in 1957, Dukes would commit 300 fouls for five straight seasons, averaging 19.5 foul outs per year. A two-time All-Star, he retired as the Pistons rebound king with 4,986 points.

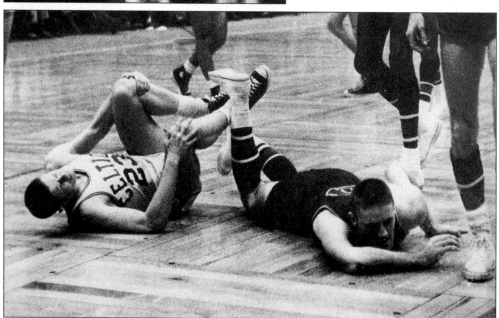

MID-COURT COLLISION, 1959. Boston Celtics forward Frank Ramsey lies on the floor in pain after his collision with Detroit Pistons forward Joe Holey during a hard-fought game in January. The Celtics won a cliff-hanger in overtime with a score of 119–118. Boston would win the Eastern Division and the NBA crown, while Detroit placed third in the Western Division.

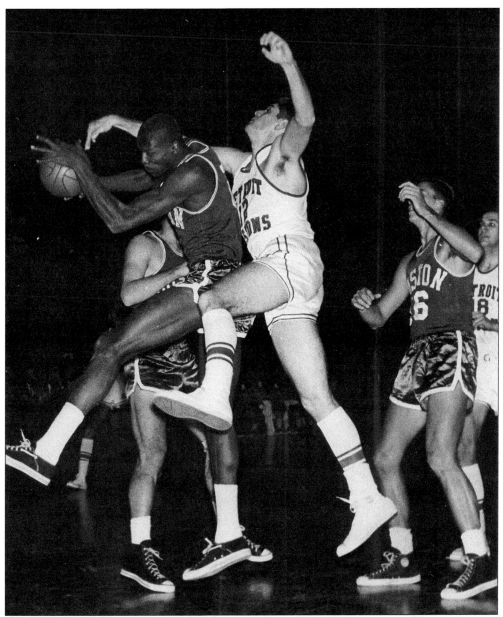

CAN'T REACH THE REBOUND, 1959. Detroit's Ed Conlin is beaten to a rebound by the Boston Celtics great Bill Russell in a game played at the University of Detroit. The Pistons lost to the Celtics in double overtime, 132–129. At the mercy of the Red Wings Olympia scheduling, the Pistons played some games at the University of Detroit and one game at the Grosse Pointe High School gym, their playoff opener against the Minneapolis Lakers, which the Pistons lost in the last minute. The team was able to move out of the Olympia in 1961 and into the new convention center on the Detroit River.

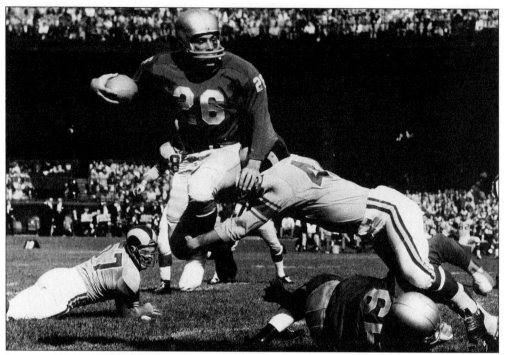

LEAPING LION, 1957. Lions running back Gene Gedman leaps right out of his shoe in the Lions-Rams game at Briggs Stadium. Detroit beat Los Angeles 10–7 in front of over 55,000 paying customers in their march to a championship. Gedman didn't score a point but did make sizeable gains in yardage all day.

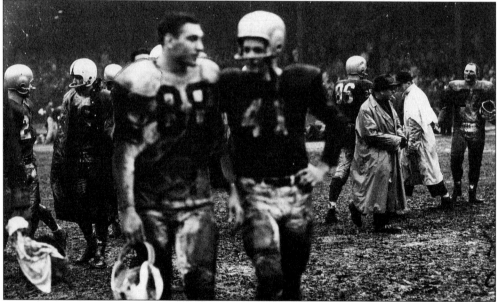

UNIVERSITY OF MICHIGAN ALUMNI, 1957. Friendly enemies Ron Kramer (#88) and Terry Barr (#41) were teammates at Michigan in 1956 and held an alumni meeting after the Lions defeated the Green Bay Packers 18–6. Kramer had a busy day with four receptions for 68 yards. Barr spent the day chasing him.

NOWHERE TO GO, 1957. San Francisco 49ers back Joe Perry lowers his head and plows into Lions halfback Yale Lary (#28) while Joe Schmidt (#56) grabs the other end to hold him to a six-yard gain in the third quarter. Lions tackle Darris McCord (#78) and 49ers offensive tackle Frank Morze (#53) look on.

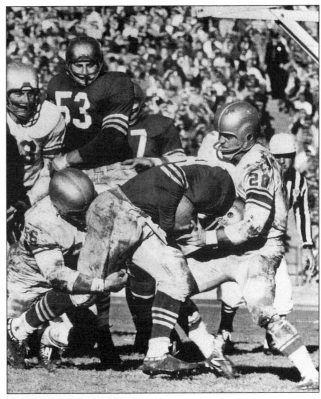

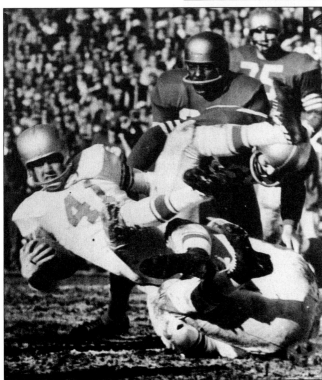

TERRY BARRED, 1957. Lions rookie Terry Barr is brought down after a punt return in Detroit's playoff game against San Francisco to determine the Western Division championship. Barr, a defensive back and return specialist, was enjoying his rookie season and helping the Lions to their fourth NFL World Championship.

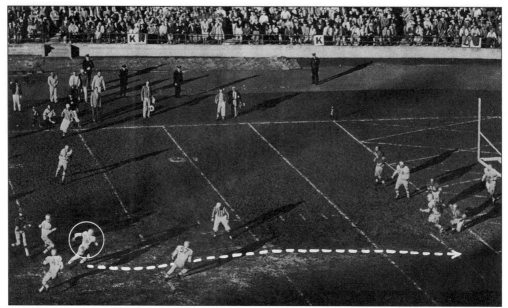

INTERCEPTION, 1957. Lions linebacker Joe Schmidt intercepts a 49er pass and returns it to the two-yard line in the fourth quarter to cap the second-longest comeback in NFL-playoff history. The Lions were down by 20 points early in the second half; they then scored three touchdowns in 4 minutes, 29 seconds late in the game.

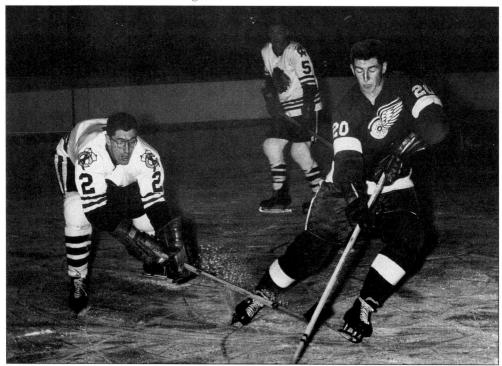

THAT WASN'T TRIPPING, 1959. Chicago defenseman Al Arbour tries to impede the Wings Len Lunde in an early-season game at Olympia. The home team won 2–1, but their dynasty had run its course. They finished fourth in the standings and lost to Toronto in the first round.

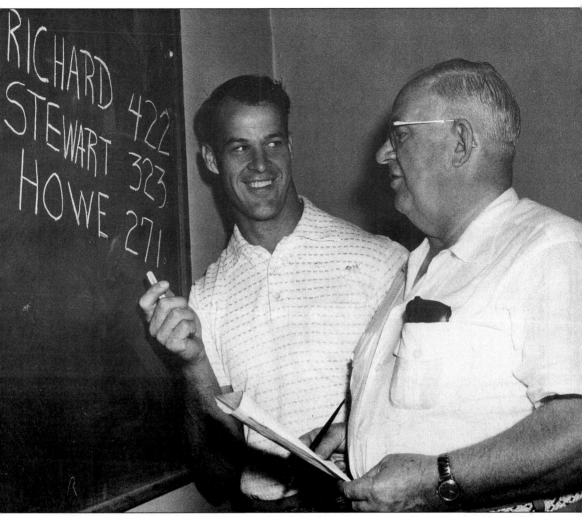

IN PURSUIT OF GREATNESS, 1955. By 1955, Jack Adams was calling Gordie Howe the "greatest" as Gordie set NHL scoring marks and began chasing the top men in goals, Nelson Stewart and Maurice "Rocket" Richard. Stewart played from the 1920s through the 1940 season, and his career mark was 323. Richard and Howe would continue their seasonal battles for goals through the 1959–1960 campaign, the Rocket's last season in the league. In 1955, Howe and Richard each had 35 goals, but Gordie had eight more assists (41–33) to beat the Rocket in scoring. The Canadiens' career mark of 544 goals would also fall to Howe.

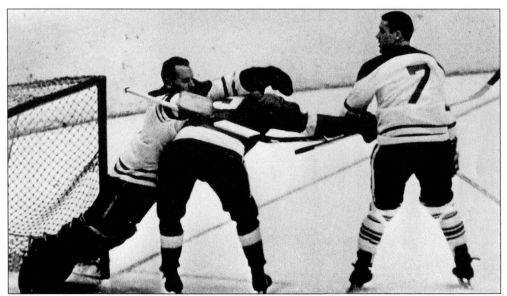

THEY'RE ALWAYS ON MY BACK, 1950S. Toronto Maple Leaf goaltender Johnny Bower appears to be wrestling with Gordie Howe while defenseman Tim Horton (#7) puts the clamp on his stick. Bower just stopped a shot from Norm Ullman, and Gordie is skating in, looking for the rebound. The two teams have a healthy rivalry.

AUTOGRAPHS PLEASE, 1950S. Fans of all ages lie in wait outside the Red Wings locker room for their favorite players to appear. Dandified Red Wings Gordie Howe (rear) and Ted Lindsay (front) oblige their followers by autographing programs. Teen-age girls appear to be the most ardent of Detroit hockey lovers.

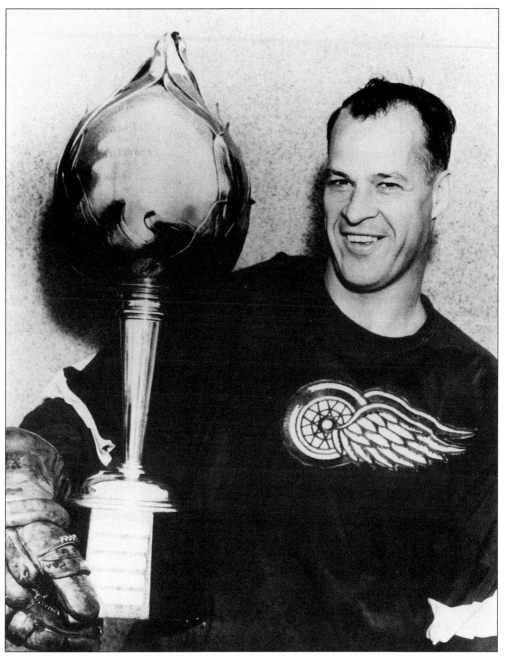

THE HART TROPHY WINNER, 1958. Gordie Howe holds the Hart Memorial Trophy that was presented to him for being the most valuable player on the team. Inaugurated in 1923 by Dr. David Hart in memory of his father, Cecil Hart, manager and coach of the Montreal Canadiens, it is given to the player most valuable to his team across the league. Howe would receive this trophy six times in his career, in 1952, 1953, 1957, 1958, 1960, and 1963. During the 1950s, Howe elevated his game beyond the legend status. He was the most complete player in the league, eliciting the comment from a rival player that "there are only four teams in the league: Montreal, Toronto, Chicago and Howe."

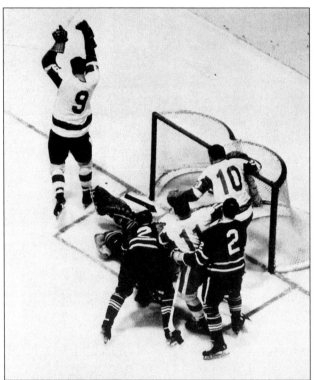

A Happy Howe, 1950s. Gordie Howe (#9) raises his stick in triumph as he puts one past Toronto Maple Leafs goalie Johnny Bower, who appears buried beneath a pile of players. Toronto's Bobby Baun (#21) and Carl Brewer (#2) can't stop the Red Wings surge led by Howe, Gary Aldcorn (#11), and center Alex Delvecchio (#10).

Sign on the Dotted Line, 1959. Fern Flaman (left) of the Boston Bruins and Detroit's own Gordie Howe (right, sporting a nasty game souvenir) are kept busy furnishing autographs at the annual Face-off Dinner at the Veterans' Memorial Building. Proceeds from the event went to help finance the youth hockey programs in the Recreation League.

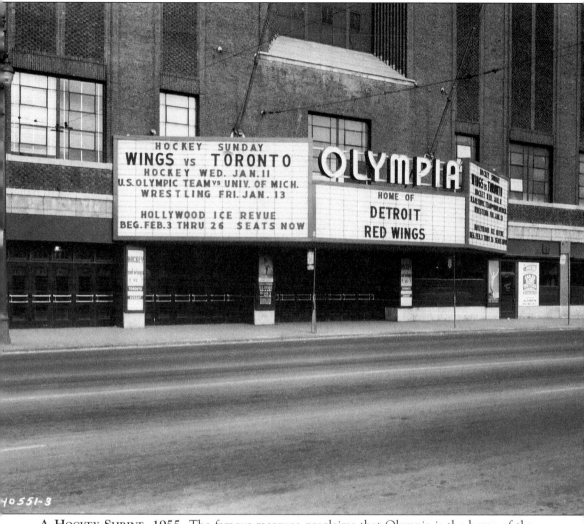

A HOCKEY SHRINE, 1955. The famous marquee proclaims that Olympia is the home of the Detroit Red Wings. Nothing would draw more fans than a game against the Toronto Maple Leafs. Once the home of the largest indoor skating rink in the United States, Olympia was known for its outside design and inside refrigeration system. It was a monument to construction in the modern age and remained unaltered until 1965, when the northeastern part of the building was enlarged to allow for 1,800 additional seats. But the aging of the building, the decline in the neighborhood, and the need to increase revenues soon forced the club to newer digs. The last game played was an old-timers versus current Red Wings event held on February 21, 1980. The last goal scored at Olympia was scored by Gordie Howe.

GORDIE INKS ANOTHER CONTRACT, 1959. Head coach and general manager Jack Adams supervises while Red Wing legend Gordie Howe signs on for more hockey action. Howe would complete his 13th season in the NHL in 1959 and would score 28 goals and 45 assists to go along with 46 minutes in penalties.

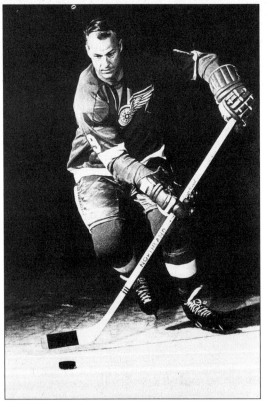

MR. HOCKEY, 1946–1971. Gordon Howe was born in Floral, Saskatchewan, in 1928 and came to the Detroit club as a Galt Red Wing graduate at the ripe old age of 18. He played his first Red Wings game on October 16, 1946, and his last on April 3, 1971. He scored a total of 1,809 points, 786 goals, and 1,023 assists.

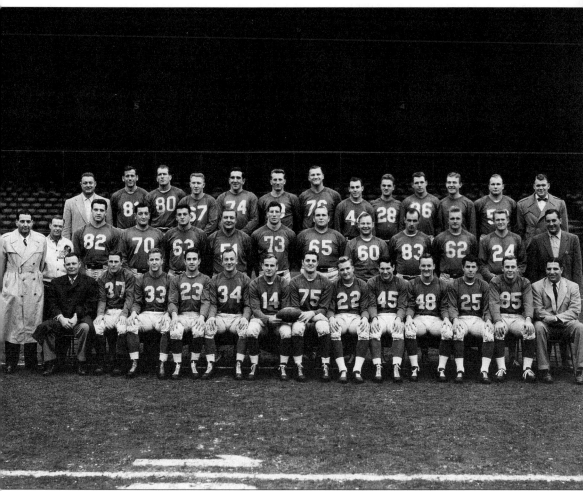

BACK-TO-BACK CHAMPIONS, 1952–1953. Pictured from left to right in this view are as follows: (front row, sitting) Coach Buddy Parker, Doak Walker, Ollie Kline, Jug Girard, Pat Harder, Bob Hoernschemeyer, John Prchlik, Bobby Layne, Bryon Bailey, Jim Hill, Jim David, Sherwin Gandee, and assistant coach Aldo Forte; (second row) W. Nick Kerbawy (general manager), Roy Macklem, Leon Hart, Gus Cifelli, Dick Stanfel, Vince Banonis, Thurman McGraw, Les Bingaman, Dick Flanagan, Jim Doran, Jim Martin, Jack Christiansen, and assistant coach George Wilson; (back row) assistant coach Garrard Ramsey, Bill Swiacki, Cloyce Box, Stan Campbell, Bob Miller, Tom Dublinski, Lou Creekmur, Don Doll, Yale Lary, Blaine Earon, Jim Hardy, LaVern Torgeson, and assistant coach Rus Thomas. Bob Smith is not pictured. This team won two World Championships in a row, both from the Cleveland Browns. The Lions went 9–3–0 in 1952 and 10–2–0 in 1953.

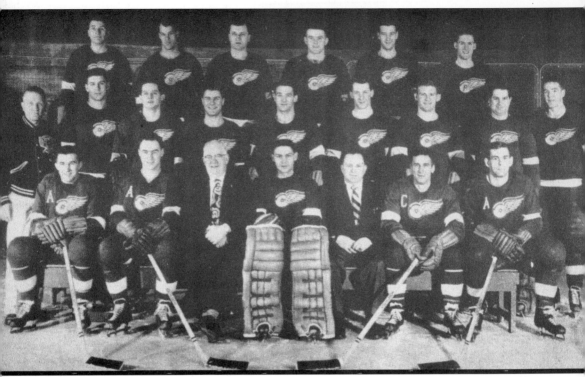

BACK-TO-BACK CHAMPIONS, 1953–1955. Pictured from left to right are as follows: (front row) Marty Pavelich, Red Kelly, Jack Adams, Terry Sawchuck, Jimmie Skinner, Ted Lindsay, and Bob Goldham; (middle row) Carl Mattson, Alex Delvecchio, Dutch Reibel, Tony Leswick, Marcel Bonin, Bill Dineen, Johnny Wilson, Lefty Wilson, and Marcel Pronovost; (back row) Vic Stasiuk, Gordie Howe, Benny Woit, Jim Hay, Glen Skov, and Larry Hillman. The dominant team in the National Hockey League during the 1950s, the Detroit Red Wings won four Stanley Cups in six years and eight league titles in nine years, beginning in 1948. There are seven honored members of the Hockey Hall-of-Fame in this photo. Back-up goaltender Glen Hall, who became the eighth member, is not pictured.